Van Eyck

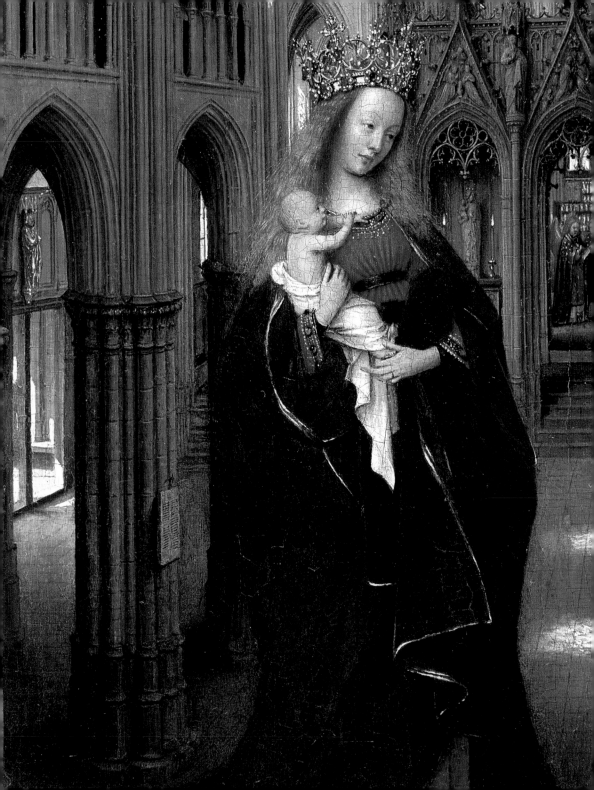

Van Eyck

Simone Ferrari

PRESTEL

Munich · London · New York

Front cover: *Ghent Altarpiece* (detail), see pp. 47, 49
Frontispiece: *Madonna in a Church*, see p. 73
Back cover: *Man in a Turban*, 1433, see p. 87

© Prestel Verlag, Munich · London · New York, 2013
© Mondadori Electa SpA, 2007 (Italian edition)

British Library Cataloguing-in Publication Data: a catalogue record for this book is available from
the British Library; Deutsche Nationalbibliothek holds a record of this publication in the Deutsche
Nationalbibliografie; detailed bibliographical data can be found under: http://dnb.dnb.de
The Library of Congress Number: 2012954640

Prestel Verlag, Munich
A member of Verlagsgruppe Random House GmbH

Prestel Verlag
Neumarkter Strasse 28
81673 Munich
Tel. +49(0)89 4136 0
Fax +49(0)89 4136 2335

www.prestel.de

Prestel Publishing Ltd.
4 Bloomsbury Place
London WC1A 2QA
Tel. +44 (0)20 7323-5004
Fax +44 (0)20 7636-8004

Prestel Publishing
900 Broadway, Suite 603
New York, NY 10003
Tel. +1 (212) 995-2720
Fax +1 (212) 995-2733

www.prestel.com

Prestel books are available worldwide. Please contact your nearest bookseller or
one of the above addresses for information concerning your local distributor.

Editorial direction: Claudia Stäuble, assisted by Franziska Stegmann
Translation from Italian: Clare Costa
Copyediting: Chris Murray
Production: René Fink
Typesetting: Wolfram Söll, designwerk
Cover: Sofarobotnik, Augsburg & Munich
Printing and binding: Elcograf, Verona, Italy

FSC
www.fsc.org
MIX
Paper from
responsible sources
FSC® C018290

ISBN 978-3-7913-4826-1

Contents

Introduction

It is a case of once seen, never forgotten. Today, Jan van Eyck's magnificent *Ghent Altarpiece* is still in its original location inside St Bavo's Cathedral, Ghent, but it has been relocated within the interior of the building to a place where it can be better admired, and in an ambience that befits the masterpiece. In a similar way, Piero della Francesca's *Madonna del Parto* was relocated from its original site in a small cemetery chapel in Monterchi, to its current residence in an old school house that has been specifically adapted to house the painting. These days, van Eyck's apocalyptic Lamb is surrounded by an atmosphere of breathless silence. No one is allowed to talk in the cathedral, and visitors are given an obligatory audio-guide. Anyone who dares utter even a whisper is admonished in no uncertain terms. When I saw the work for the very first time it was still situated in the chapel dedicated to the donor, Joos Vijd, where it was consecrated on 6 May 1432. It returned there in 1920, after a turbulent history involving moves, thefts, and restorations, and it had become the subject of many copies. A full-size photographic representation now hangs in place of the original. Whilst the painting was still in the small chapel, it was necessary to purchase a ticket to view it, and the whole process did indeed involve an element of theatre: every so often the sacristan would approach the altarpiece, and slowly and reverently close its wings so that the external side could be seen. The gesture was accompanied by a long creaking sound, as other figures came into view, rather like the figures on an old-fashioned clock tower. The wings were then firmly closed, concealing the luxuriant green of the grass, the gold brocade of the angels, the rich red robe of God the Father, and the shimmering vestments of the blessed. It was as if a somber bell had tolled, and there was an almost imperceptible

shift in atmosphere. The muted colors of the exterior—white, gray, ivory, and mother-of-pearl—seemed to invite a more sober reflection, and an atmosphere of peace descended on the Gothic chapel. The space within its confines was immune to any external noise or activity; the archbishops reclining on their tombs had fallen silent, and even the wooden lion on the pulpit had ceased his roar. Then the footsteps of the sacristan could be heard again, and with a practiced gesture the wings were opened once more, and the chapel was flooded with light and color. The painting can be read as an illustration of Revelation, with the Lamb symbolizing Christ's death and Resurrection; the Alpha and Omega. It seems an appropriate theme for an altarpiece that also constitutes the Alpha and Omega of Flemish painting, the pinnacle of the art produced in that era. The opening of the wings was always accompanied by a sense of breathless anticipation until the entire width with its twelve panels was revealed it in all its magnificence. No criticism could possibly be leveled at such a work, representing as it does the very highest level of technical and artistic achievement, unparalleled in fifteenth-century Flemish painting. According to the beliefs of the time, the beauty of the created world reflected the beauty of its Creator, and accordingly van Eyck portrays a world of exquisite beauty, both natural and man-made, down to the tiniest detail of a daisy petal or a gleaming pearl. Unlike his Florentine contemporaries, he did not concentrate on the human figure, but afforded equal importance to the glorious abundance of the natural world as the place where the divine meets the human, and his art is all the richer for it.

Stefano Zuffi

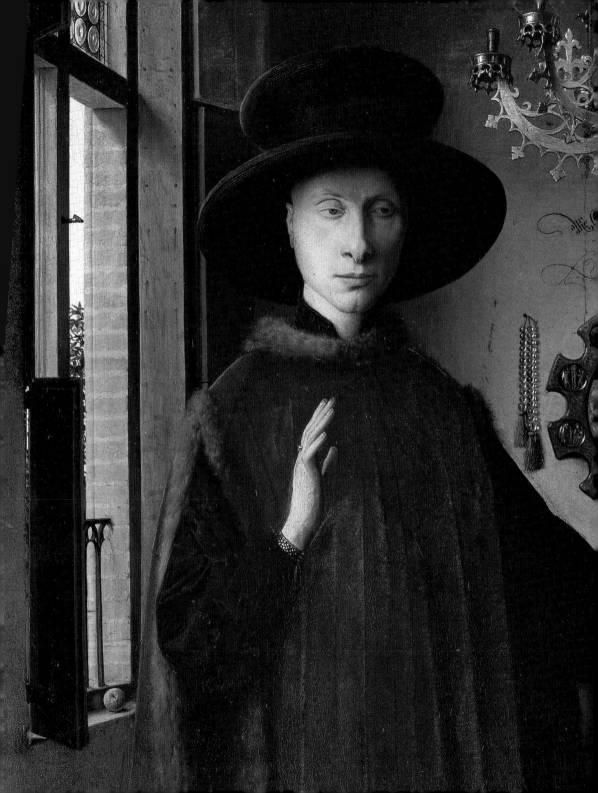

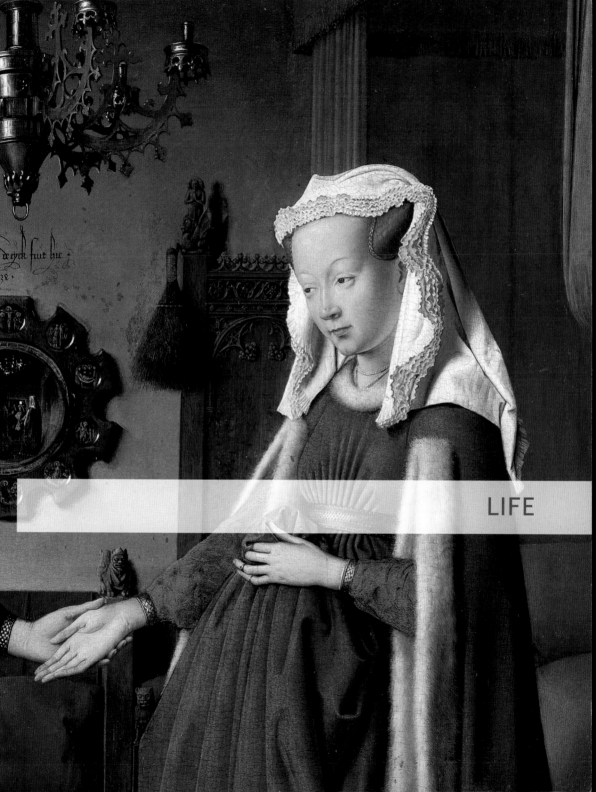

LIFE

Van Eyck and Flanders

Jan van Eyck's artistic journey began in Flanders, the cradle of the Northern Renaissance, which occurred simultaneously with the Florentine Renaissance in Italy. The prestigious expansion of the Burgundian Court provided the ideal atmosphere in which to foster his unprecedented artistic talents. Whether in The Hague, Lille, Bruges, or Tournai, van Eyck was the fortunate recipient of many privileges, which subsequently enabled him to develop a new school of European painting. With his eye for detail, his close observation of the world, and his use of light he foreshadowed the great masters of the seventeenth century such as Vermeer.

A region of continual change

In the late fourteenth century and the first half of the fifteenth century, the territories that now comprise the countries of France, the Netherlands, and Belgium were divided up very differently, and were subject to a succession of political upheavals. Northeast of Paris was Flanders (Bruges), the Duchy of Brabant (Antwerp), Holland, and Limburg (Lièges). Further south was the Duchy of Burgundy, which gradually encroached upon the territories listed above, even reaching as far as Paris during the reign of John the Fearless (r. 1404–1419), in 1408. This process of annexation had begun in 1384 under Philip the Bold (r. 1363–1404), and was continued by Philip the Good (r. 1419–1467), who transferred the capital to Brussels. Undergoing a rapid economic expansion, the whole region had become one of the most important centers of commerce in Europe. The cities in that region still house the masterpieces of Renaissance art that were produced in their heyday. In the fourteenth century Ghent, the birthplace of Charles V, had the second highest population in the region after Paris. The marriage of Margaret of Flanders to Philip the Bold, Duke of Burgundy, in 1369 marked the beginning of a golden era for Bruges. Philip the Good later established his court there in 1429, and after his marriage to Isabella of Portugal the couple embarked on an exuberant and lavish court lifestyle. Marriages and other important occasions were celebrated on a spectacular and imaginative scale, and proved to be some of the most memorable events

Opposite page: detail of The Crucifixion, attributed to the workshop of van Eyck, c. 1440–1450, Galleria Franchetti at the Ca' d'Oro, Venice.

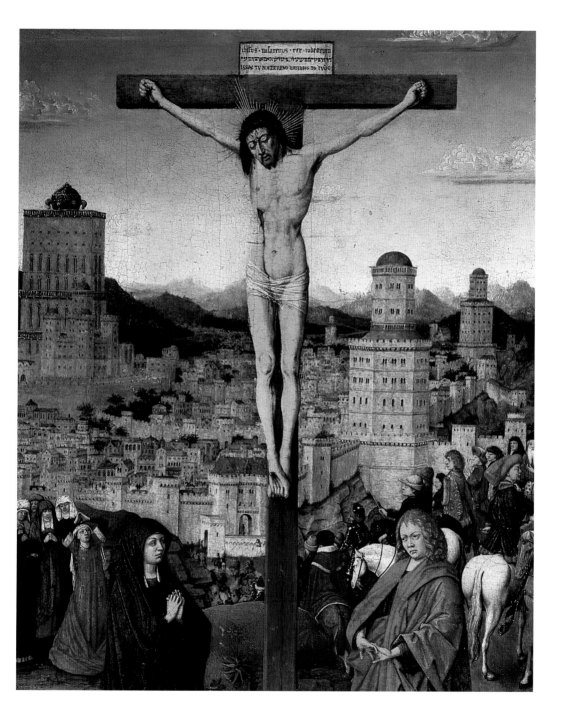

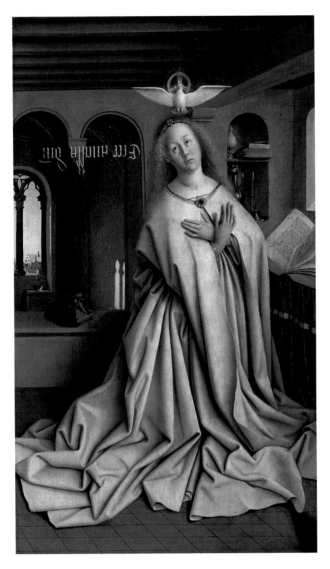

presence there. By the sixteenth century, the population reached a hundred thousand, and the city came to rival Bruges not only in size but also in its reputation for pomp and ceremony.

During the fifteenth century Brussels benefited from the presence of the Dukes of Burgundy, and became a flourishing center of artistic excellence, as exemplified by the work of Rogier van der Weyden. However, this fortuitous combination of art and commerce was relatively short-lived, for the following century brought a period of war and instability, resulting in the shifting of political power to other geographical locations and to other dynasties, such as the Hapsburgs, with a subsequent loss of power and prestige for Brussels.

The Duchy of Burgundy was another territory to enjoy a particular flowering of the arts during a period of prosperity, greatly assisted by the enlightened patronage of Philip the Bold and Philip the Great. The center of artistic activity was the city of Dijon, and the nearby Chartreuse de Champmol, a Carthusian monastery founded by the two Dukes, provides a good example of the results of their patronage. The Flemish artist Melchior Broederlam (c. 1350, after 1409) painted the wings of its magnificent altarpiece in the late four-

Detail of The Annunciation from the Ghent Altarpiece, 1424–1432, St Bavo's Cathedral, Ghent.

the epoch. During the fifteenth century, the port of Antwerp flourished due to international maritime trade, and the competition between trading countries anxious to establish a

teenth century, predominantly in the Late Gothic style, with its attention to detail and narration at the expense of spatial verisimilitude. The other artist involved, and perhaps of even greater relevance, was Claus Sluter (1340s–1405/1406), born in Haarlem. He carved the portals of the charterhouse, along with the tomb of Philip the Bold. His life-size figures were sculpted with a realism as yet unprecedented in the north, and predating that of Donatello (c. 1386–1466), in Italy. The dimensions of Sluter's sculptures were not conceived in subordination to architectural considerations, nor to the strictures of Gothic linearity.

Education and influences

Jan van Eyck has been called "the Masaccio of Flanders," an epithet that justifiably puts him on an equal footing with the Tuscan master of innovation. Whilst there can be no dispute as to the caliber of the artist, his origins are the subject of much speculation and dispute. His date of birth remains unknown, though it was likely to have been between 1390 and 1395, and the location was probably the town of Maaseyck (Maaseik), which is now in Belgium but at that time lay within the Duchy of Burgundy. Some sources maintain that he was born in Maastricht. Between 1422 and 1425 he is documented in records as court painter at The Hague, in the service of Philip the Good, Duke of Burgundy. By this stage he was working as an independent artist, and therefore was probably in his thirties, hence the estimated date of his birth. It is not known where his apprenticeship took place, whether in Flanders or in France, the two being in close proximity geographically and politically, given the expansion of the Duchy of Burgundy, but also culturally. At the end of the fourteenth century, Netherlandish painters and sculptors were working for Charles V, King of France, and for the brothers Philip and Jean, Dukes of Burgundy and Berry respectively. There could have been many occasions when the young Jan might have encountered them. One of the most significant factors in his artistic development would have been the International Gothic style, which was well established across the courts of Europe in the late fourteenth century and the first half of the fifteenth. This widespread cultural climate embraced an autonomous style that was completely independent of the Italian Renaissance. Its artistic language was anchored in the Gothic style of expression, with minute attention to detail

and naturalism, but with little attempt at logical perspective. Unlike the innovations occurring in Tuscany, this style did not break with local tradition. The transition between the naturalism of the medieval North and the naturalism developed by van Eyck was a smooth and untroubled one, unlike the swift developments and abrupt changes that were occurring in Italy. This idea is explored in a study by the Dutch scholar Johan Huizinga entitled *The Autumn of the Medieval* (1919, translated as *The Waning of the Middle Ages*) in which he seeks to relate this epoch to that of the Italian Renaissance in a manner that avoids the usual stereotypical labels such as the "Dark Ages" or "Modern Era."

Van Eyck's naturalistic style has been interpreted as "the consummation of the late medieval artistic spirit." Without undermining the significance of the Flemish artists in their development along Renaissance lines, it is true that they adhered to what was best about the medieval style in terms of decorative elements and the use of symbolism. When discussing the late Gothic or International Gothic styles there is always a danger of trivializing them, of reducing them to their most inferior imitators. It is worth remembering that this style manifested the passion for color, elegance, and

design that was demonstrated by sovereigns, aristocrats and members of the court circles during that era. It was a style that had a natural affinity with the French and Burgundian courts. Amongst the artists active in the Duchy of Burgundy was the Franco-Netherlandish painter Jean Malouel (c. 1365–1415), who produced a number of works for the Chartreuse of Champmol, and an accomplished tondo of the Pietà, now in Paris. The results produced were of the highest quality, and included many works in miniature. This latter genre, often unjustly relegated to one of the "minor arts," was well suited the illustration and decoration of manuscripts, usually in the form of watercolor or tempera on parchment, paper, or papyrus. Illuminated manuscripts became coveted collectors" items, and Duke Jean de Berry became one of the most avid collectors, in particular of the work of the Limburg brothers. These talented Flemish miniature painters have traditionally been considered as role models for van Eyck. The importance of Jean de Berry as a patron of the arts is attested by the renowned Book of Hours, now in Chantilly, which he commissioned. The devotional calendar is illustrated with figures wearing the costumes of the day, carrying out various tasks at court. In 1416 both the Limburg brothers, along with their

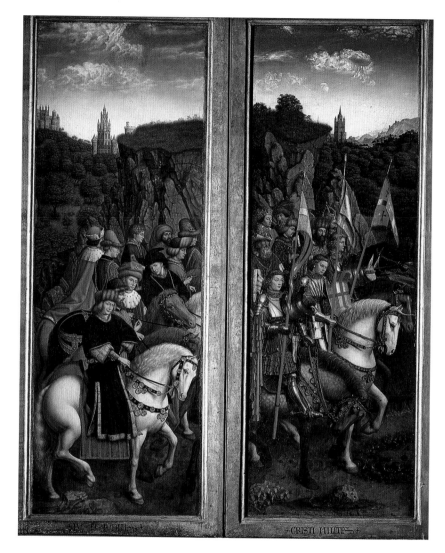

patron, perished in an outbreak of the plague that year. There is a theory (see Luciano Bellosi, in *Prospettiva*, 1975) that some pages of the book had not yet been completed by the time of their deaths. For example, the months of October and December show a style of dress that was not contemporary, but in fact more similar to the later miniatures decorating the *Chronicles of Hainaut*, compiled for Philip the Good in 1446.

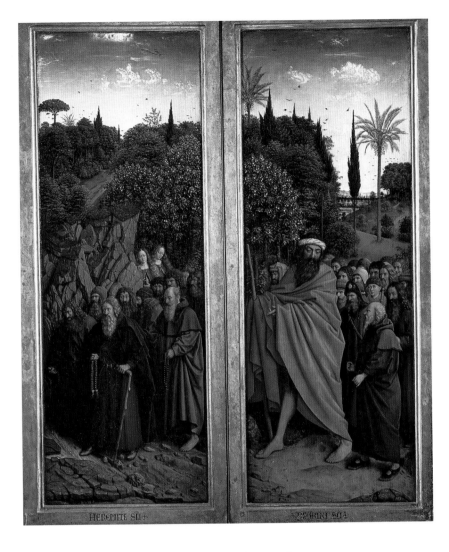

The 1420s

In addition to the influences of the Late Gothic style in painting, van Eyck would have been familiar with the significant developments of French Gothic painting, as seen in the work of Jean Fouquet, and the Burgundian sculptures of artists like Sluter.

Whilst in Florence Brunelleschi was designing the dome of the cathedral of Santa Maria del Fiore, and Masaccio was painting his *San Giovenale Triptych*, van Eyck was working in the service of Count John of Bavaria,

prince bishop of Liège, and brother of William IV, Count of Hainaut, Holland, and Zeeland. Between 1422 and 1425 he is documented in records from the Holland Treasurer's office, and is specifically mentioned as "valet de chambre," or court painter. More precisely, he is mentioned as being employed, from 24 October 1422 until 11 September 1424, in the decoration of the palace of the Count of The Hague. Other documents attesting to his activities indicate the existence of two assistants, a fact that would seem to confirm that his own period of apprenticeship was over by now, and that he was running his own workshop, one destined for the international scene. No more than traces survive of his artistic activity during this period, but the fact that in 1422 he was referred to as "maestro" would indicate that he must have been at least twenty or twenty-five years of age by then. In the service of John of Bavaria, he worked on miniatures for the book now known as the *Turin-Milan Hours* (originally the *Très Belles Heures de Notre Dame de Jean de Berry*), a complex illuminated manuscript, incomplete, whose composition spanned several decades and that contains elements both of the Late Gothic style and of Renaissance naturalism. It is almost impossible to conceive of it in its entirety, due to the fact that early on it was divided up amongst different owners, and a large section of it was destroyed by fire in 1904, though thankfully it had been photographed by then. One section of it was purchased in the nineteenth century by Gian Giacomo Trivulzio for his famous library in Milan, where it became known as the *Milan Hours*. In 1935 it passed into the hands of the Civic Museum in Turin, hence its current name, the *Turin-Milan Hours*. The work was originally commissioned by Jean de Berry, and later stages of it were commissioned by John of Bavaria. During the first phase, the manuscripts were decorated by the Limburg brothers, and subsequent phases of its evolution were entrusted to van Eyck. Interestingly, experts seem to agree on the likelihood that van Eyck was not working alone on these illuminations, but with the help of a mysterious figure—his older brother, Hubert van Eyck.

The mysterious brother

The figure of Hubert van Eyck has remained shrouded in mystery due to the scarcity of evidence surrounding his existence. The earliest evidence dates from 1409, when a payment was made to "magister Hubertus pictor" ("master Hubert, painter") for an altarpiece painted for a religious institution for noble

women in Tongeren. One of his works is mentioned in a bequest made to the daughter of Jan de Visch van der Capelle in 1413, and he is mentioned in a few other documents dated 1424, 1425, and 1426, some pertaining to the city of Ghent. There is enough evidence to confirm that he was not a figment of some historian's imagination, but a real artist who played a role in Flemish art. Archives confirm that he died in 1426, and mention is made of an inscription in his memory made in copper.

Further documentary evidence of his existence can be found in the inscription on the frame of the *Ghent Altarpiece*, which indicates that the work was initiated by Hubert, and completed by his younger brother Jan in 1432: "The painter Hubert van Eyck, one greater than whom is not to be found, began the work; Jan, his brother, second in the art, completed the difficult task at the request of Joos Vijd. The latter invites you with these verses to admire the created work on 6 May (1432)." Most art critics are agreed that the three large figures in the upper register were executed by Hubert. Despite the monumentality of the figures, which was in itself an innovation, the backgrounds painted by Hubert are lacking in depth, resulting in a rather compressed and less realistic effect.

His hand has also been discerned in the lower register, where he seems likely to have been assisting Jan in various details, although it is clear that Jan was the main author. It remains difficult to establish the true extent of his output, and the subject has remained a matter for much debate amongst art historians. In addition to his involvement in the Ghent Altarpiece, Hubert is said to have painted *The Three Marys at the Tomb* in Rotterdam, though this work too was completed by Jan, and also to have illuminated some sections of the *Turin-Milan Hours*. With relatively little to go on, any conclusions about his style must be made with caution, but it would appear that he adhered more to the International Gothic style than his brother did, and therefore his artistic language was more conservative and far less revolutionary.

1425: The court of the Duke of Burgundy

Immediately after the death of John of Bavaria (6 January 1425), Jan van Eyck went to Bruges, where he was appointed court painter in the service of Philip the Good, Duke of Burgundy, a position of considerable prestige. The salary and privileges bestowed on him with this appointment are a

measure of the degree of fame and success that must have already surrounded him. Documents mention "honors, privileges, exemptions, liberties, rights, profits and emoluments," and this at a time when painters, particularly in Italy, were subject to the whims and caprices of their patrons, who did not always treat them generously. Whilst the exact nature of these privileges remains unclear, their very existence was an exceptional circumstance. Philip the Good paid him an annual salary of one hundred livres, and even permitted him to work for clients outside the court, a fact that was unheard of for court painters at that time. Sadly, the nature of van Eyck's "special duties" is somewhat mysterious, as is the case with his previous patron, John of Bavaria, but many of his commissions would have involved the production of coats-of-arms, banners and ephemeral decorations for tournaments and festivals, much as Leonardo da Vinci created for Ludovico di Moro, Duke of Milan. There is no doubt that the pomp and ceremony of the court would have provided many opportunities for van Eyck to exercise his skills and creativity.

This court appointment first entailed a move to Lille in 1425, the administrative capital of the Netherlands, where he remained until 1428.

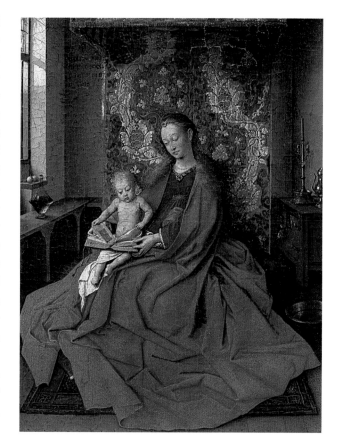

During this period he was entrusted with many prestigious commissions, several involving journeys. Account books mention payments made to him for a "pilgrimage" made on the Duke's behalf, and for a journey to "certain distant lands," the identity of which was deliberately concealed. The secrecy surrounding these journeys has resulted in a great deal of useless and extravagant speculation about their nature, much

Virgin and Child (Ince Hall Madonna), 1433, National Gallery of Melbourne, Victoria.

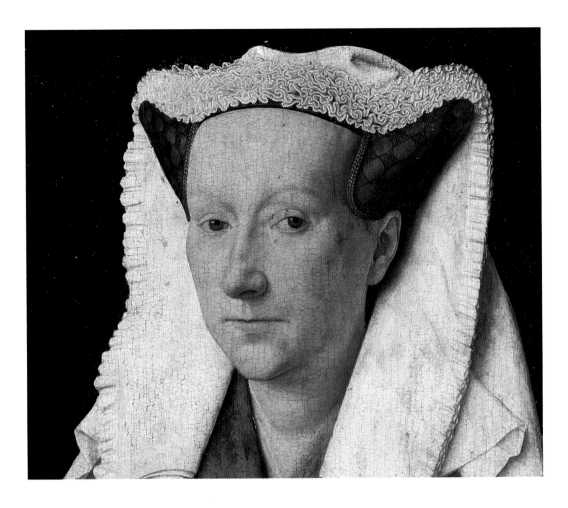

Portrait of Margarete van Eyck (detail), 1439, Groeningemuseum, Bruges.

like the speculation surrounding the identity of the Mona Lisa, or the precise meaning of Piero della Francesca's *Flagellation of Christ*. It is possible that one of the secret journeys involved a pilgrimage to the Holy Land, from which the artist would have returned with numerous sketches of the places he had visited. Such a commission may well have been connected with Philip the Good's intention of launching a new Crusade, following in the footsteps of his father, Philip the Bold. If these were to have been the case, the commission would have demonstrated Philip's faith in van Eyck not only as a faithful and talented chronicler, but also as a trustworthy man capable of complete discretion. This suggestion

is lent some weight by the topographical accuracy of views of Jerusalem, such as the Omar mosque, the Church of the Holy Sepulcher, and Solomon's Temple, found in his painting of the Crucifixion (New York) and Three Marys at the Tomb (Rotterdam). By the same token, the chains of snow-capped mountains portrayed with such accuracy in his works were very likely the result of his own observations of the Pyrenees whilst visiting Spain and Portugal.

1427–1428: other travels and court obligations

Jan van Eyck traveled regularly whilst residing in Lille, twice to the town of Tournai (1427 and 1428). On the first occasion, 18 October 1427, the Feast of St Luke (the patron saint of painters), he was invited there to attend a banquet given in his honor by the local guild of artists, at which he is likely to have met Robert Campin (known as the Master of Flémalle) and Rogier van der Weyden. In 1428 he undertook an important mission on behalf of the Duke of Burgundy, when he participated in a delegation to Portugal to negotiate the marriage of Philip the Good and Isabella of Portugal. Van Eyck painted two portraits of the Portuguese princess on canvas, which were sent back to her suitor. The mission was highly successful, and resulted in the marriage of the couple in 1430, an event of such magnificence that it became famous throughout the whole of Europe.

1432: a year of triumph

In 1432 Jan moved from Lille to Bruges, where he was to remain until his death in 1441. The move marked a new chapter in his life, artistically and socially. The Bruges councilors and other dignitaries paid an official visit to his house, and in the same year he completed his masterpiece, the Ghent Altarpiece, which was consecrated in the cathedral of St Bavo on 6 May, according to the inscription on the frame. The presence of such an inscription bearing the artist's name was in itself an innovation in an epoch when paintings were not usually signed, and were usually the product of a workshop rather than an individual. It marked a shift in the status of artists and in the concept of authorship. It was no coincidence that from that year onwards van Eyck began to sign and date all of his paintings. That same year he painted the famous *Portrait of a Man*, which is in the National Gallery, London.

Bruges: city of opportunity

In van Eyck's time, Bruges was the most important center of commerce in northwest Europe, and so he would have come into contact with a diverse array of potential clients. The presence there of the Burgundian court was a further element in its centrality, which was further assured by the tactical matrimonial policies of the Dukes Philip the Bold and Charles the Rash, who married Margaret of York in 1468. Amongst the members of the ducal entourage, van Eyck painted Baudouin de Lannoy, governor of Lille and court chamberlain, whose acquaintance he made during the diplomatic mission to Portugal of 1428. Another dignitary who became one of his patrons was Cardinal Niccolò Albergati, the Papal ambassador in France and Spain. In addition to these noble figures, commissions began to come in from people with differing backgrounds and economic means. As a center of international maritime trade, merchant ships bearing all manner of cargoes arrived on a regular basis from all areas of the known world. This intense activity fostered a new class of citizen, the bourgeoisie, whose members appreciated art, both as an object of aesthetic contemplation and as a status symbol. Favorable trading conditions led to an increase in wealth, which in turn led to a higher demand for luxury items, including works of art. Once, the world of art had been the domain of the Church and the aristocracy; now it had opened up to a varied and ever-increasing market. Portraits were most in demand. The Ghent Altarpiece had already been commissioned by a wealthy citizen, Joos Vijd, and now Jan found himself with other clients from the new social class, such as the Italian merchant Giovanni Arnolfini (who was welcomed at the court of Philip the Good), and Jan de Leeuw, one of the most renowned goldsmiths in Bruges.

1434: a year of personal and professional triumph

Van Eyck had already painted several portraits, including *A Man in a Turban* in 1433, prior to embarking in 1434 upon the portrait that was to become his most famous work, *The Arnolfini Marriage*. Quite apart from the interpretation of the painting, which has generally been read as the consecration of a marriage, it is highly significant from a socio-historical point of view. In a break with the traditional typology of portraiture, van Eyck painted his subjects, who belong to the wealthy bourgeoisie, as full-length figures, something that

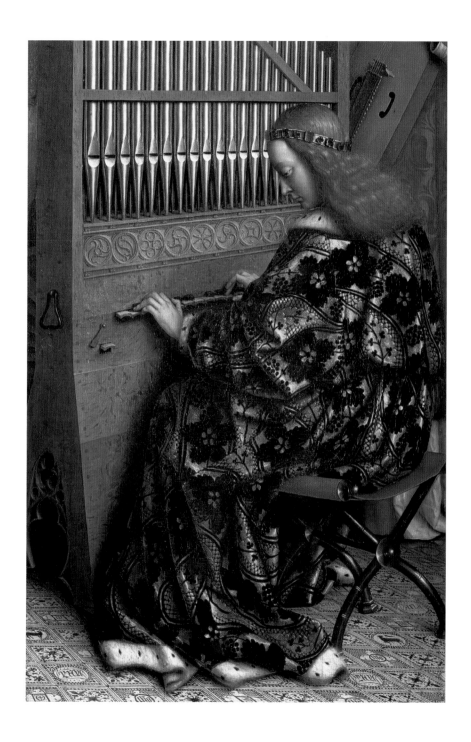

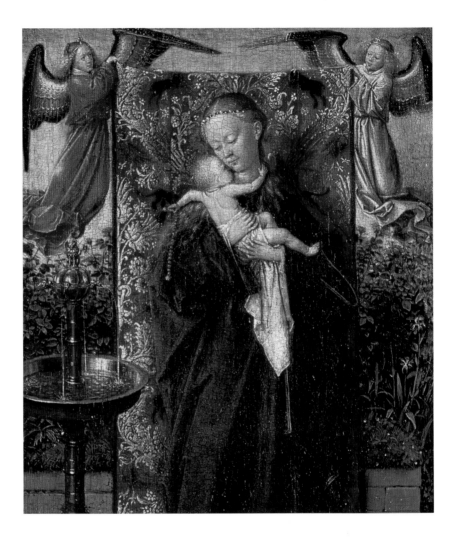

had usually been reserved for the most powerful sovereigns of Europe. It is not surprising that the artist should have come into contact with an Italian family, given the conspicuous presence of Italian merchants in Bruges. They were importers of spices, fabrics, sugar cane and other goods, and tended to live in communities based on their town of provenance, be it Florence, Genoa, Lucca, or Venice. The branch of the powerful Medici bank that was located in Bruges was the largest outside of Italy.

The year 1434 also marked a joyous episode in the life of van Eyck and

his wife Margarete, whose portrait hangs in the Groeningemuseum in Bruges, for that year they celebrated the birth of their first son. Philip the Good was godfather to the child, and on the occasion of the christening he presented the artist with six silver goblets made by Jean Peutin.

1435: controversy and recognition

Even the most illustrious career is subject to moments of uncertainty, and for van Eyck this came in 1435, when the treasurer's office in Lille refused to pay his salary, which the duke had just increased to three hundred and sixty livres. Van Eyck turned to the duke for help, threatening to resign from his position. The duke intervened personally and wrote to his officials, demanding that they pay the money immediately. In the letter he refers to the artist's involvement with as yet unfinished projects, and declares the impossibility of finding another artist so knowledgeable in both the arts and the sciences. This was an extraordinary accolade for the time, the concept of the "Renaissance man" being in reality an invention of the nineteenth century. A contemporary of van Eyck's, the Italian humanist Bartolomeo Facio, declared him not only to be gifted as an artist, but also to be well versed in literature and geometry, and an avid reader of Pliny. Whilst not on a par with a humanist such as Leon Battista Alberti, van Eyck clearly manifested many of his attributes. His talents lay not only in the execution of his works, but also in his innovative ideas. Flanders was not party to the intellectual and artistic debates that characterized the Renaissance in Italy, but van Eyck came as close to them as was possible in his world. Although he lived and worked at some distance from the hotbed of Renaissance dialectics, he contributed nonetheless to some of the topics under discussion, such as the argument concerning the supremacy of the art of painting over the art of sculpture, or vice versa. Famous artists, including Leonardo and Michelangelo, wrote on the subject, their arguments ranging from the sublime to the ridiculous, whereas van Eyck's contribution to the debate was implicit in his work. Of particular relevance here was the winged altarpiece, a form of church decoration that featured in the northern Renaissance, and which he used to great effect in his Ghent Altarpiece. It involved the arts of painting, sculpture, and carpentry, all of which were used to create a wonderfully ornate work of art. Traditionally in this

Diptych of the
Crucifixion and the
Last Judgment (detail),
c. 1425,
Metropolitan
Museum of Art,
New York.

genre, the paintings were less highly prized than the intricate wooden carvings, but van Eyck turned that idea on its head. In his altarpiece, every possible surface of the interior is painted, whilst the exterior is not only painted three-dimensionally—in the lower register it has figures painted to resemble marble sculptures, each housed in its individual niche. The figures of the patron saints are painted in monochrome (grisaille), and the flanking figures of the two donors on either side are painted in polychrome. The illusionary effect of the "statues" is heightened by the inclusion of a painted plinth. This trompe-l'oeil is continued on the inside, with the forefathers of the church portrayed as tiny statues in a niche. The figures of Adam and Eve, however, are designed to resemble real flesh and blood rather than stone or wood.

Artist and diplomat

From the autumn of 1434 onwards, van Eyck was commissioned by Bruges city council to work on the gilding and polychromy of six stone statues of the Counts of Flanders for the façade of the Town Hall. This seemingly humble task was not an uncommon one at the time, and was by no means looked down upon by the artists themselves. For van Eyck, it was a practical and public task that helped to remove the aura of mystery that still surrounded him. It was not without its technical demands either, for the addition of color needed to enhance rather than diminish the plasticity of the whole. Vasari's prejudice against the combination of color and sculpture had prompted a return to more classical forms of sculpture, as later exemplified by the pure white marble statues of Canova. However, this sentiment was not in keeping with the sensibilities of an epoch in which color was an important element in pomp and ceremony, and a key element in portraying a range of emotions. Painting, sculpture, and architecture were not compartmentalized in a rigid manner, but seen as complementary, sometimes overlapping, forms of art, even when not practiced by the same artist. Given this context it is easier to understand why van Eyck was entrusted with this particular task.

In 1436 Jan van Eyck undertook his last mission on behalf of the Duke, one that took him to "foreign lands." The actual destination and purpose of the trip are, yet again, unknown. That same year it seems that he made the acquaintance of René of Anjou, who was held prisoner by Philip the Good until the following

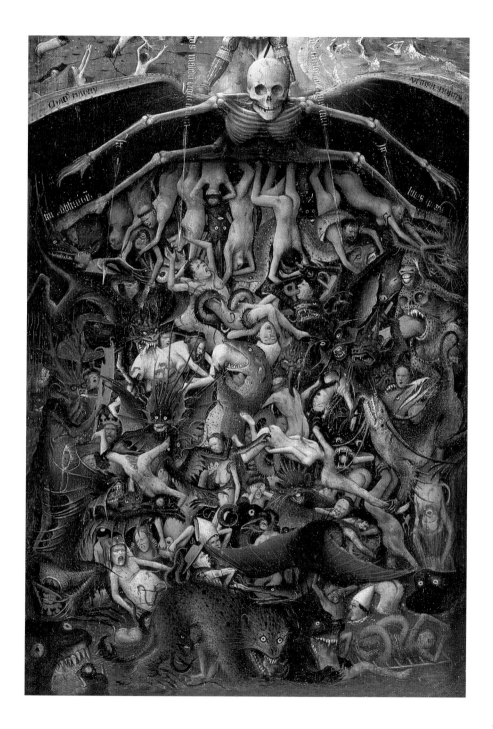

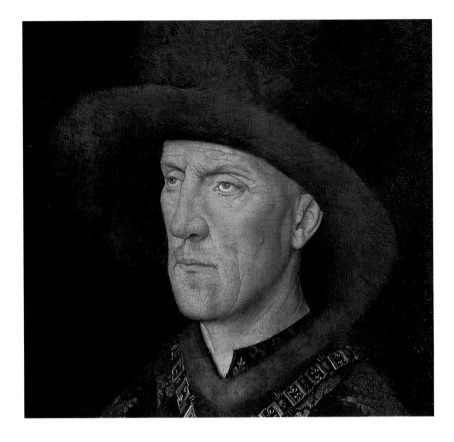

year. Legend has it that van Eyck was responsibly for teaching him to paint, using the revolutionary technique of painting in oils. 1436 was a momentous year in the history of art, for in that year Leon Battista Alberti published his famous treatise *De Pictura* in the vernacular, thus allowing the general public to learn the correct method for painting in perspective.It symbolized the convergence of science and art, and it changed the course of painting for ever. On a smaller scale, in the microcosm of Flanders, van Eyck's development of the technique of oil painting marked a similar turning point.

Final years

Van Eyck's work continued unabated and undiminished until his death in 1441. In fact, all of his paintings after his collaboration on the Ghent Altarpiece were executed during the final decade of his career. During this time

he worked in different genres: working in miniature he created the exquisite *Triptych of the Virgin and Child* (1437); his *St Barbara* (1437) shows an innovative compositional strategy; and his *Madonna at the Fountain* (1439) shows his mastery of devotional painting. In the final years of his life he appears to have been active as Philip's intermediary. For example, he made an advance payment to a miniaturist who was undertaking a commission for the Duke. During this fruitful period he also painted the *Portrait of Margarete van Eyck*, his wife, in 1439, when she was thirty-three years old. He seems to have married her around 1433, and she is described in Burgundian documents as "damoiselle Marguerite," which implies that she was of noble descent. Some hypotheses have been advanced to suggest that Philip may have instigated the match, encouraging his favorite painter to marry someone of an elevated social status in order to enhance his own. It seems a likely move on the part of a generous and pragmatic patron.

Van Eyck's legacy

There is a well-defined nucleus of paintings that can be securely attributed to van Eyck. In addition to this known oeuvre there are numerous works whose authorship remains disputed. Many of these are today considered to be the products of his workshop (several of the dates actually post-date his death in 1441), but they certainly bear the hallmarks of the master's style. Some of the paintings from his workshop became famous in their own right, such as *The Crucifixion* (c. c. 1440–1450), now housed in the Galleria Franchetti at the Ca' d'Oro in Venice), which shortly after its completion found its way to Italy and was copied by artists there. The authorship of some paintings is disputed between van Eyck and Petrus Christus (c. 1410/1420–1475/1476), the other master of the northern Renaissance, whilst others were left unfinished and completed posthumously by members of his workshop.

Van Eyck died in the summer of 1441, and was buried in the churchyard of St Donation's in Bruges. The following year, at the request of his brother Lambert van Eyck, his remains were exhumed and he was laid to rest in a privileged location within the church interior, close to the baptismal font. It seems an appropriate act of homage to an artist who contributed so much to the development of the art of painting, and who had been an esteemed member of court and trusted aide to the Duke.

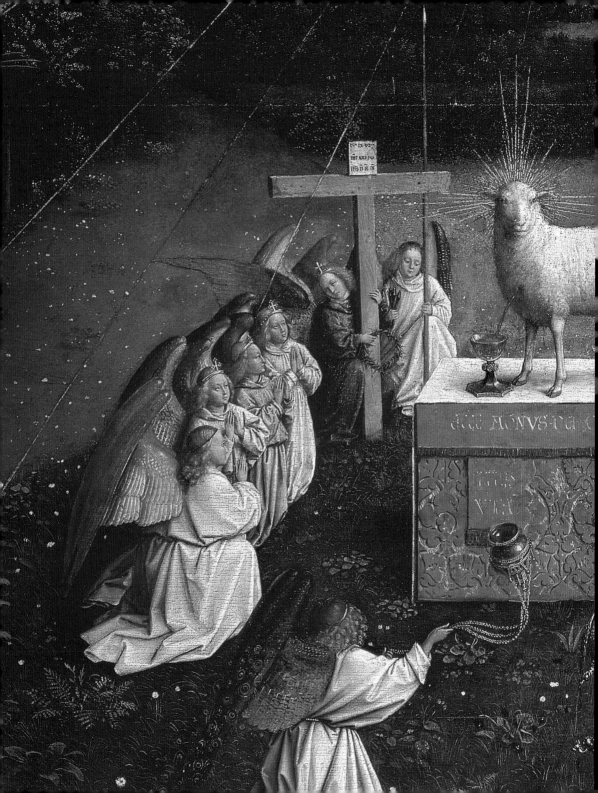

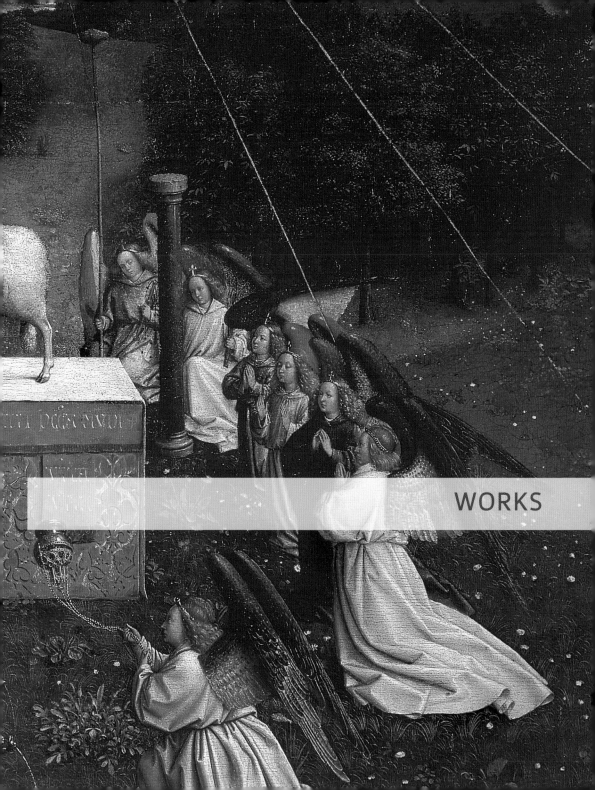

WORKS

Birth of John the Baptist, from the Turin-Milan Hours

c. 1422–1424

Miniature on parchment, 28 x 19 cm
Museo Civico, Turin

The *Turin-Milan Hours* is a highly contested work, both in authorship and chronology, being the product of several decades and changing circum-stances. It may have been started as early as 1417, but seems more likely to date from the beginning of the next decade. The *Birth of John the Baptist* is undoubtedly the work of van Eyck: the tiny interior is executed in a "modern" style, filled with exquisitely painted minuscule objects. The sense of perspective is heightened by the depiction of three receding rooms, an extraordinary illusory device. Van Eyck uses a repeated geo-metric pattern to help achieve this effect: the rectangular frame of the painting is echoed in the shape of the bed with its canopy, the window, and the adjoining doorway on the right. Despite the numerous figures and objects depicted within the confines of a small space, there is no sense of overcrowding. Whilst the upper scene is Italianate in its use of perspective, the *Baptism of Christ* in the lower scene (also clearly by van Eyck) bears the hallmarks of Flemish landscape painting at its most impressive. Here the sense of space is not created by means of geome-try or architectural devices, but through subtle gradations of color and tone. He uses a low horizon to show a river apparently receding into the distance, drawing the eye towards the distant mountains.

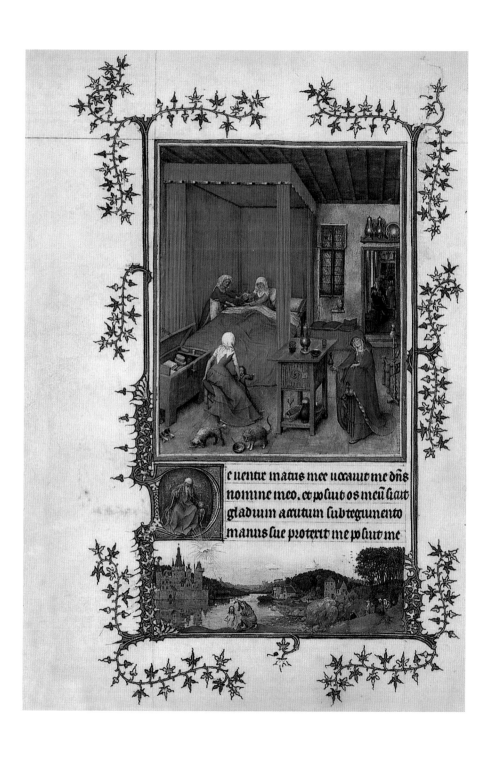

e uentre matris mee uocauit me dñs
nomine meo. et posuit os meu sicut
gladium acutum sub tegimento
manus sue protexit me posuit me

Mass of the Dead, from the Turin-Milan Hours

c. 1422–1424

Miniature on parchment, 28 x 19 cm
Museo Civico, Turin

The *Mass of the Dead* accompanies the Requiem Mass in this Book of Hours. The artist overcomes the constraints of such a tiny space with a bold and innovative scene in which architecture is the main subject. A Gothic choir is shown in all its architectural detail: pilasters, arches, windows, galleries, and ribbed cross vaulting, creating a sense of great height and depth. Instead of the conventional focal point in the center, van Eyck chooses a slanting view, from left to right. His choice of Gothic architecture is in itself significant, and highlights the difference in attitude between him and his Italian counterparts. Whereas the Italian Renaissance sought to distance itself from all that was medieval, van Eyck deliberately selected that style of architecture for his painting. His choice was in keeping with the more understated Northern Renaissance, which retained a sense of continuity between past and present, unlike the more revolutionary spirit behind the Italian Renaissance. This sense of continuity with the past was not only true stylistically, but also spiritually, for that epoch was still a deeply spiritual one. Johan Huizinga explores this idea in his study *The Autumn of the Medieval* (translated as *The Waning of the Middle Ages*) and van Eyck's exquisite miniature seems to confirm his thesis. The bas-de-page illustration depicting a cemetery scene is more conventional in style, which has given rise to some suggestions that it may have been painted by another artist.

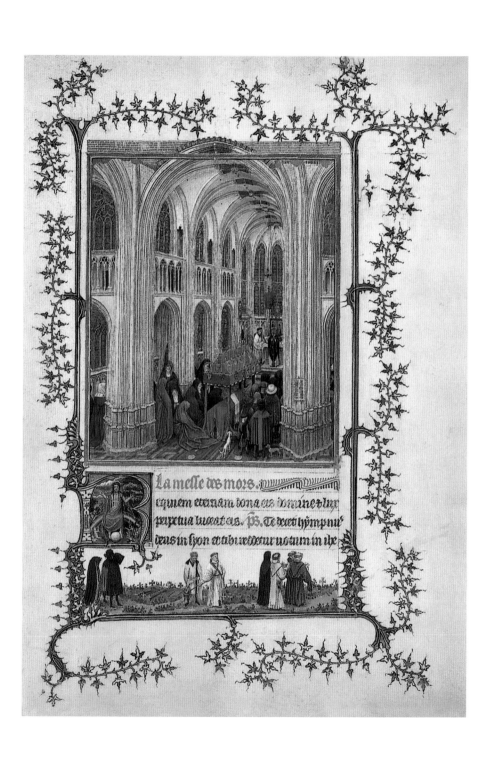

Ghent Altarpiece, closed

1424–1432

Oil on panel, 375 x 260 cm
St Bavo's Cathedral, Ghent

The *Ghent Altarpiece* is the largest and most complex work produced by van Eyck, and his most famous. It also represents a founding work of Flemish painting. It comprises twenty-four panels in the traditional form of a winged altar that could be opened or closed according to the church calendar or occasion. Both the interior and exterior would normally be painted, and sometimes featured sculptures as well. The polyptych remained a popular format in the Northern Renaissance, whereas in Italy single altar panels were now being chosen in preference to the multi-paneled versions, which were deemed obsolete. It is known that the work was a collaboration between Jan van Eyck and his mysterious brother Hubert, who died in 1426. The inscription also identifies the donor, Joos Vijd, a wealthy and influential Ghent citizen, who is shown on the lower register, along with his wife and the two patron saints St John the Baptist and St John the Evangelist. The upper register shows The Annunciation, and right at the top the Prophets and Sibyls who foretold the events of the New Testament. Despite the monumentality of the figures and the luminosity of the upper register, the altarpiece in its closed position does not quite represent a coherent whole. The different figures are of varying sizes, and there are different axes of symmetry in the various panels. However, this does not detract from the extraordinary quality of the paintings. X-ray photographs taken during the last major restoration have revealed some alterations to the original painted outlines.

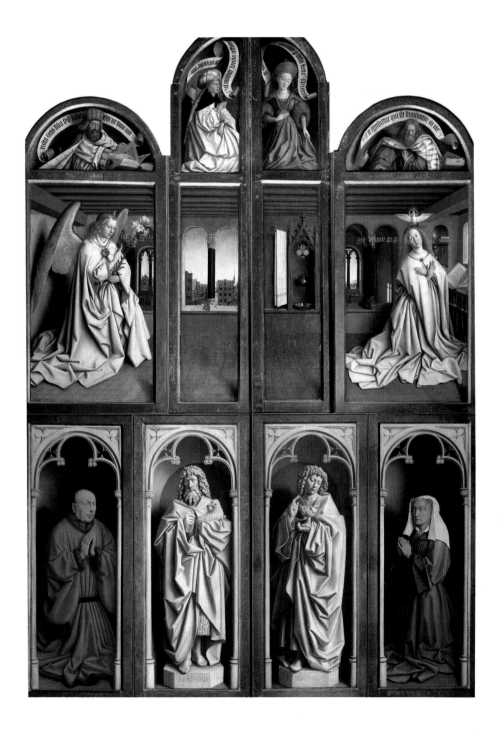

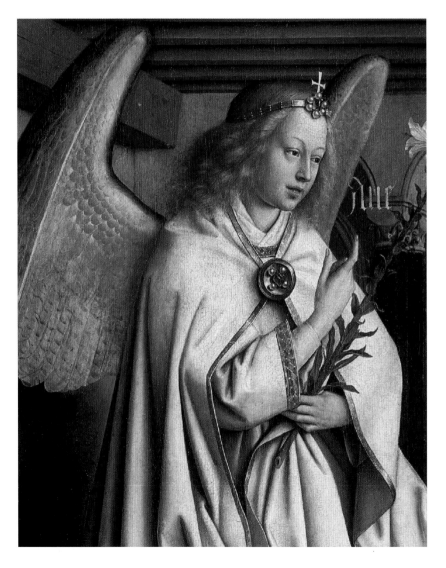

*Ghent Altarpiece,
closed (details)*

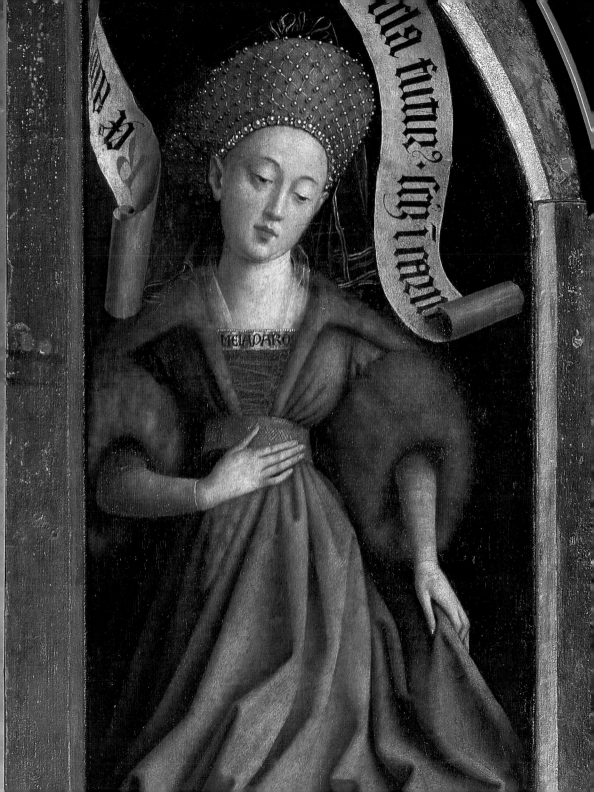

Ghent Altarpiece

1424–1432

Oil on panel
St Bavo's Cathedral, Ghent

The story of the Annunciation has inspired some of the most extraordinary scenes not just of fifteenth-century art, but of the entire history of art. It is a pivotal moment in the story of Christianity, when the Archangel Gabriel appears to the Virgin Mary. Bearing a lily, symbol of purity, he addresses her with the words: "Hail Mary, full of grace, the Lord is with you." Van Eyck approaches the traditional scene with original and innovative ideas in terms of light, landscape, and still-life painting. The figures are illuminated in a manner that emphasizes the folds of their garments, rendering them sculptural in form. What is most striking about the scene is the view seen through the open arches of the windows, a device which establishes the sense of perspective. On the left, a mullioned window has been designed according to Alberti's precepts, and the cityscape visible has been identified as that of Ghent. On the right, the space has been defined by means of a niche set into the wall, and a towel hanging on the diagonal, both giving a sense of depth. Everyday objects, portrayed with a breathtaking attention to detail, are imbued with allegorical significance. For example, the lavabo and ewer set into the niche resemble liturgical utensils. These still-life arrangements foreshadow the development of still-life painting as a genre in its own right that began the following century with Caravaggio.

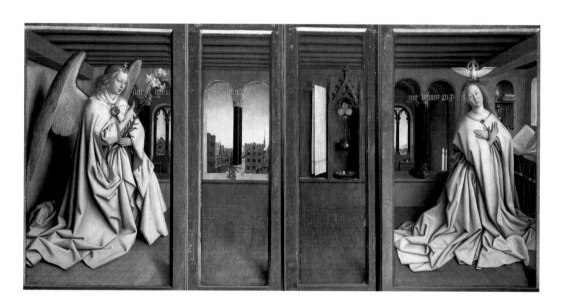

Ghent Altarpiece, Joos Vijd and St John the Baptist

1424-1432

Oil on panel
St Bavo's Cathedral, Ghent

These two panels are significant for several reasons. Firstly, they are expressions of pictorial virtuosity; secondly, they contribute to the Renaissance debate concerning the supremacy of painting over sculpture, or vice versa; thirdly, they revolutionize the traditional type of polyptych; fourthly, they herald a new vogue in the art of portraiture. The illusionism here is unprecedented, and it invites the viewer to make a comparison between the painted figure and the "sculpted" one. St John the Baptist is portrayed as a statue resting on a plinth, whilst the figure of the donor, Joos Vijd, resembles one of the brilliantly painted statues that were popular during the Middle Ages and Renaissance. Van Eyck asserts his own opinion that painting is superior to sculpture because it can create an illusion of sculpture through trompe-l'oeil effects such as this one. In the past, carved wooden figures had been an integral part of the design of polyptychs, and here the artist provides an innovative solution. In the portrait of the donor, realism triumphs over convention as Joos Vijd is shown as a full-length figure, a privilege usually reserved for sovereigns, and there is no attempt at idealization. The light plays over the figure, accentuating the folds of his robe, the softness of the fur, the prominent veins on his hands, and his balding head.

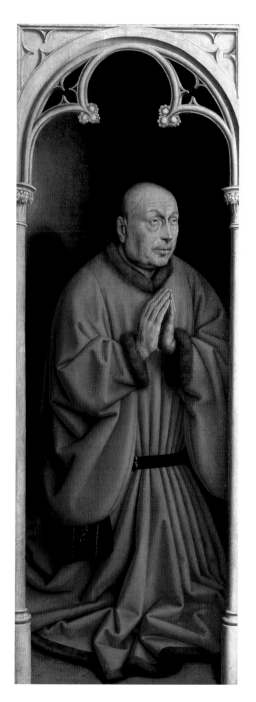
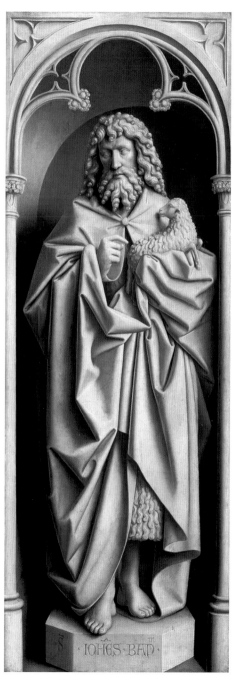

Ghent Altarpiece, The Donor's Wife Elisabeth Borluut and St John the Evangelist

1424–1432

Oil on panel
St Bavo's Cathedral, Ghent

The right half of the lower register (closed) is a mirror image of the left. The two saints are flanked by the donor and his wife, and the saint on this side is St John the Evangelist, who saw the Vision of the Lamb, according to the Book of Revelation. The portrait of Elisabeth Borluut and her husband, Joos Vijd, are amongst the earliest examples of this genre of Flemish portraiture. Her portrait is placed in perfect symmetry with his, and she too faces inwards, her hands joined together in prayer. Coming from an aristocratic family, she may well have played a role in the commissioning of the altarpiece, thus inaugurating the long line of female patrons of the arts during the Renaissance, culminating in Isabella d'Este of Mantua. The portraits combine a sculptural monumentality and an attention to intimate details. Elisabeth Borluut is portrayed in a formal pose as she kneels in prayer, but her gaze is lost in a very personal act of solemn contemplation. The figure emerges from its niche with the vigorous plasticity of Burgundian sculpture. The three-dimensionality is accentuated by the use of chiaroscuro, which defines the folds of her robes and the shadows of the niche behind her, whilst a source of light coming from the left illuminates various parts of the figure. The solidity of her two hands clasped in prayer renders the figure even more substantial, whilst the focal point of the portrait is undoubtedly the intense look of concentration on her face.

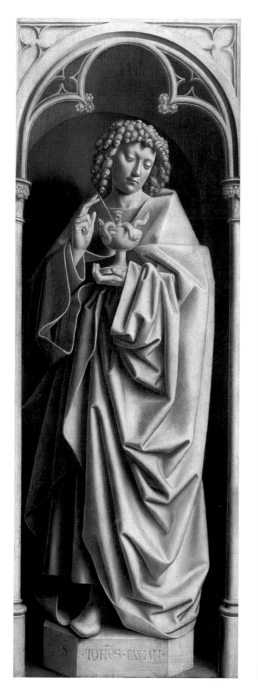

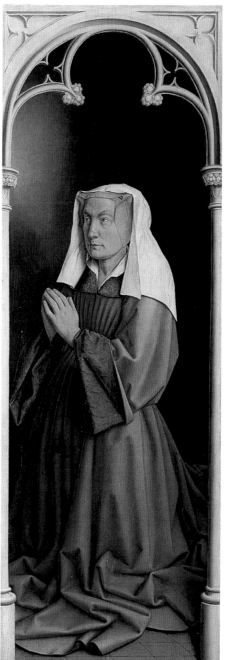

Ghent Altarpiece, open

1424–1432

Oil on panel, 375 x 520 cm
St Bavo's Cathedral, Ghent

The central theme of the open, feast-day interior of the altarpiece is the Adoration of the Lamb, a symbol of the sacrifice of Christ made for the redemption of mankind. The lack of homogeneity of the closed position is even more in evidence here, for there is no universal scale or system, the figures in the upper register being a great deal larger than those in the lower register. There is an even greater divergence in style, due to the collaboration between Jan van Eyck and his brother Hubert, who was a far less talented painter. Family workshops were common in the fifteenth century, and it has been difficult to establish the authorship of the various panels with any degree of certainty. However, it seems most probable that Jan painted the central scene showing the Lamb, whilst the less convincing *Deësis* is attributed to Hubert. The somber tonality and mood of the closed position here gives way to a spectacular feast of color and exuberance, with angelic voices singing hymns of praise to the Savior. The hosts of angels in the upper register are reflected in the lower register by the Mystical Assembly of the Blessed, who have come to worship the Lamb, a moment represented in the Liturgy by the words *Ecce Agnus Dei* (Behold the Lamb of God). There is a juxtaposition between the monumental figures of the upper register and the minute, exquisitely detailed figures of the lower register. The real protagonist of the scene, however, is the magnificent landscape that extends to every corner of the lower five panels.

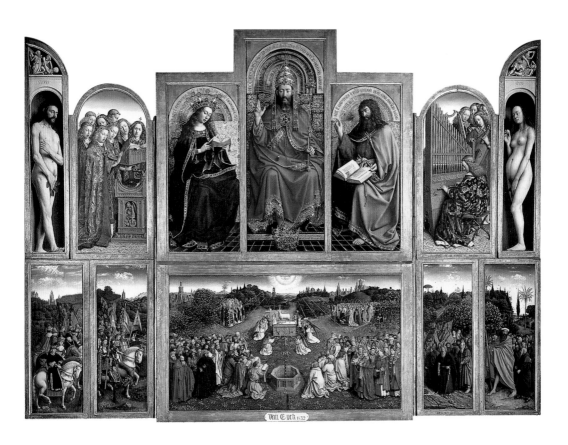

Ghent Altarpiece, Deësis

1424–1432

Oil on panel
St Bavo's Cathedral, Ghent

In Byzantine art, the Deësis was an iconic representation of Christ enthroned, flanked by the Virgin Mary and St John the Baptist. The latter figures are traditionally shown facing towards Christ, their hands raised in supplication on behalf of humanity. The inclusion of this scene in the upper register of the polyptych connects it strongly with the past, with the Byzantine era and with medieval theology and spirituality. However, there is an attempt to achieve three-dimensionality in the human forms visible beneath the folds of drapery, which is more in keeping with fifteenth century ideas, but in comparison to other Flemish works of the period, symbolism takes precedence over realism. For example, in this painting John the Baptist is shown not as a wild, unkempt figure inhabiting the wilderness, but robed in a sumptuous green mantle adorned with sparkling jewels. He is accorded the same grandeur as the other two figures, creating a harmonious scene of magnificence and opulence. The embroidered hangings that form the background to each figure reinforce the sense of symbolism, for no attempt is made to create a natural or realistic background, and there is little sense of spatial depth. This lack of attention to physical reality is the main reason why this panel has generally been attributed to Hubert van Eyck, the older brother of Jan, who is widely seen as an inferior artist.

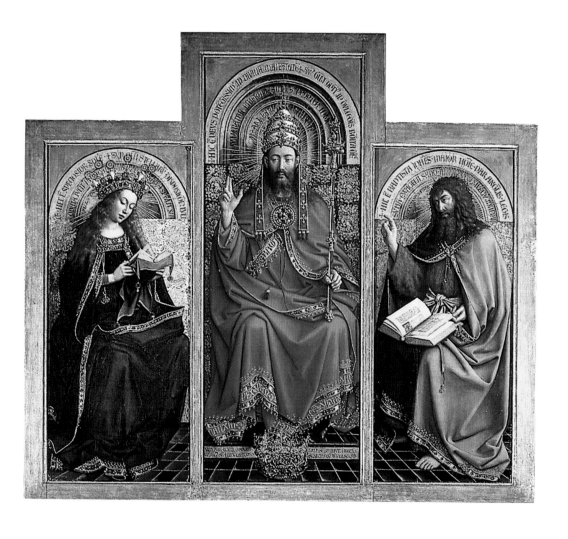

Ghent Altarpiece, The Adoration of the Lamb

1424–1432

Oil on panel
St Bavo's Cathedral, Ghent

This panel is the central scene of the whole work, both physically and theologically. The apocalyptic Lamb is being sacrificed on an altar, symbolizing the sacrifice of Christ, and his blood is flowing into a chalice. The angels surrounding the altar are holding symbols of Christ's Passion: the Cross of Calvary, the Crown of Thorns, the column where the Flagellation occurred, the spear that pierced his side, and the sponge soaked in vinegar that he was given to drink. Following the same central axis as the principal figure in the upper register, the Holy Spirit in the form of a dove radiates light over those present. The Lamb is situated directly beneath the dove, and in front of the Lamb stands the Fountain of Life, which is referred to in Revelation. Crowds are thronging to pay homage to the Lamb, the Savior of mankind: Apostles, Prophets, virgins, saints, Fathers of the Church, and martyrs. The mystic scene is depicted in a paradisiacal landscape full of botanical detail, depicting flowers from all over the world, including valerian, lily of the valley, narcissi, lilies, basil, and poppies. Van Eyck has moved away from the medieval style towards an authentic reproduction of nature, down to the most minute detail. Whereas in Italy painters at that time were preoccupied with the accurate portrayal of perspective, and were reduced the number of figures in their scenes in order to do that to better effect, here van Eyck uses the receding landscape to establish a sense of spatial depth, but attaches a far greater importance to the intricate details of the scene in a myriad of different forms.

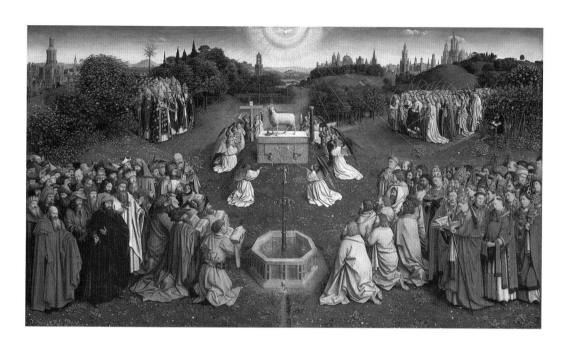

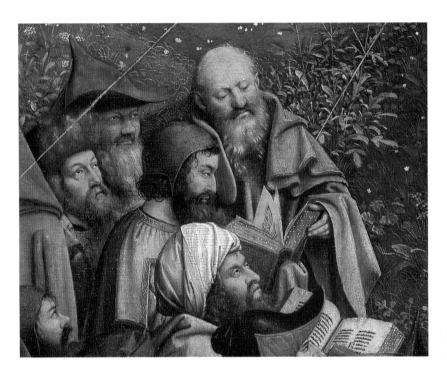

Ghent Altarpiece,
The Adoration of the
Lamb (details)

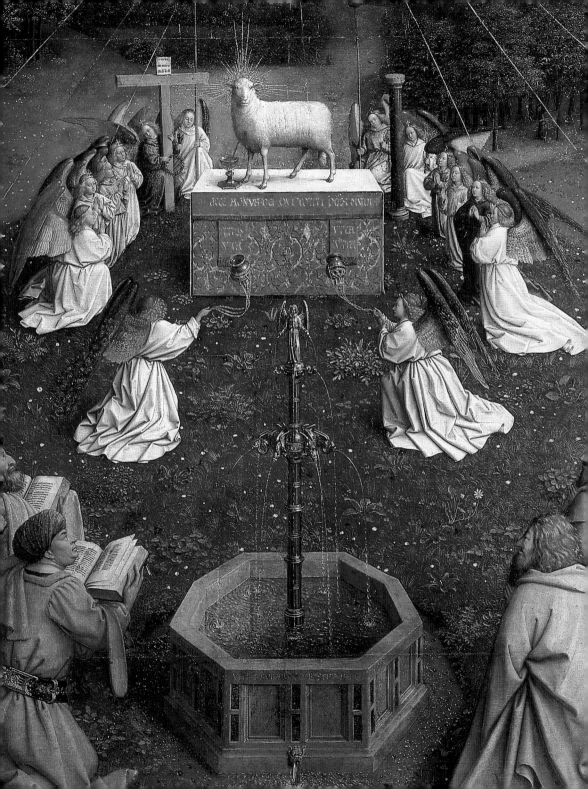

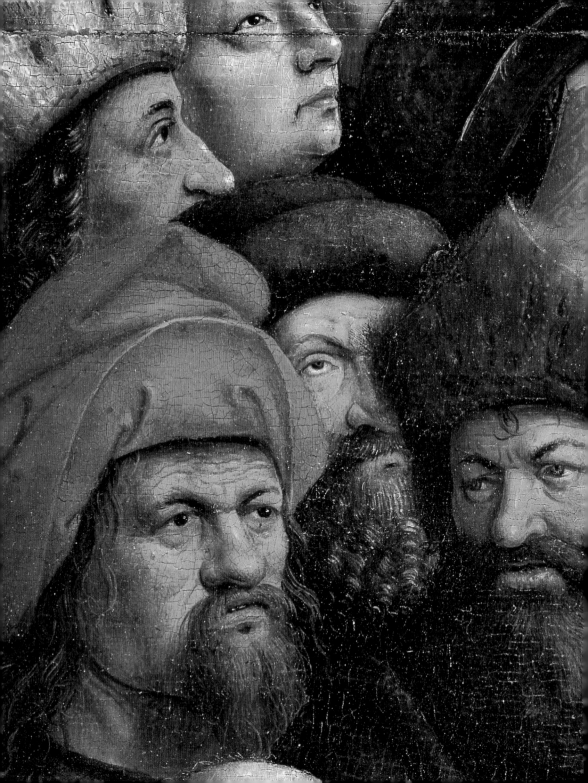

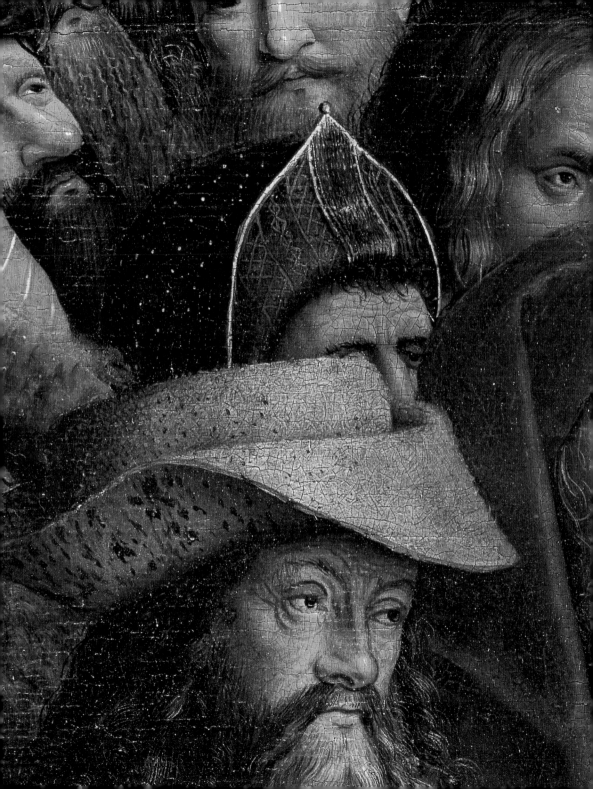

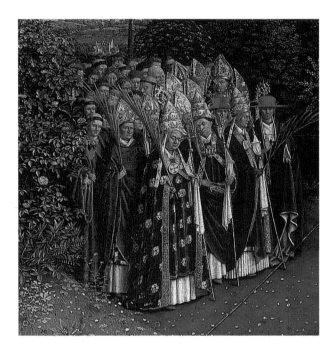

Ghent Altarpiece,
The Adoration of
the Lamb (details)

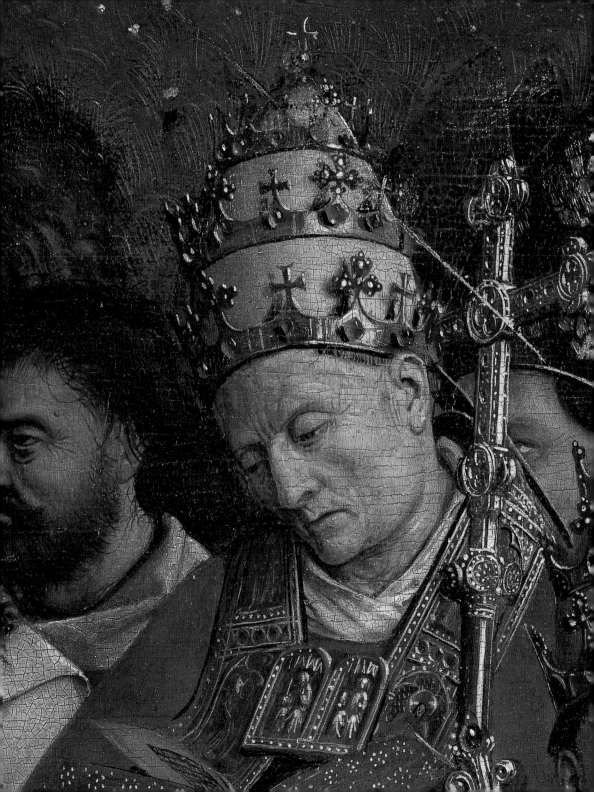

Ghent Altarpiece, Singing Angels and Music-Making Angels

1424–1432

Oil on panel
St Bavo's Cathedral, Ghent

Flanking the solid, statuesque figures of the Deësis, these angels pro-
vide a flurry of movement and activity on either side of the central panel.
The theological theme is continued through various references: the
monogram of Christ and a stylized Lamb appear on the tiles of the floor;
there are carved wooden figures of two prophets and the Archangel
Michael defeating the devil; there are inscriptions referring to the
singing of praises to God. The *Singing Angels* are perhaps the most fasci-
nating of all: they are shown in all manner of different facial expressions
as they join in the heavenly chorus, in a scene that represents the paint-
ing of van Eyck at its most animated. The detail of the musical instru-
ments bears the hallmarks of the Flemish style: of particular note are
the pipes and casing of the organ, the bellows pumped by the angel, and
the harp. Music was an important aspect of the contemporary cultural
scene, and many artists were also proficient in a musical instrument,
as befitting the concept of the universally talented Renaissance man
advocated by Baldassare Castiglione in *The Book of the Courtier*, which
was published in 1528. In Flanders, Philip the Good was a great patron
of music, which flourished at court.

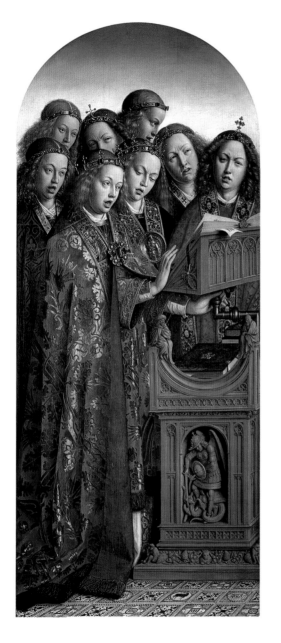
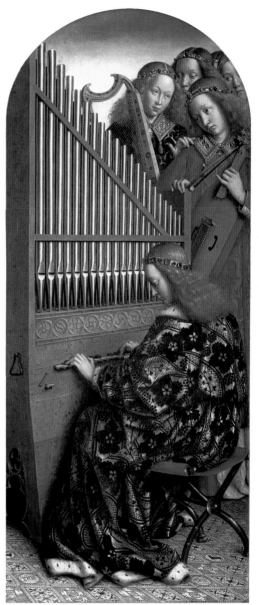

Ghent Altarpiece, Adam and Eve

1424–1432

Oil on panel
St Bavo's Cathedral, Ghent

Situated in the outermost panels of the upper register, the figures of Adam and Eve exude a powerful force over the whole register. Generally agreed to be the work of Jan van Eyck, they have been painted with a sense of spontaneity and a lack of idealization. In comparison to the celestial figures, they appear earthly, real, and thoroughly human. The darkness of the niches behind them accentuates the warmth of their flesh and blood with a luminous, sculptural intensity. Eve's generous belly symbolizes her role as mother of humanity. Adam and Eve represent the need for redemption, which had arisen through the Fall, and were usually portrayed in a dramatic manner, full of shame and remorse, like Masaccio's figures in the Brancacci Chapel in Florence. Van Eyck focuses instead on a more introspective spiritual dimension. Adam's face shows a heartfelt, but contained expression of self-reproach. Eve's expression is more enigmatic: she seems lost in melancholy thought as she gazes into the distance.

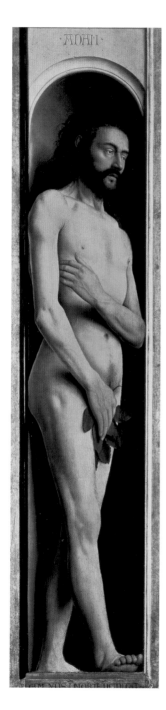
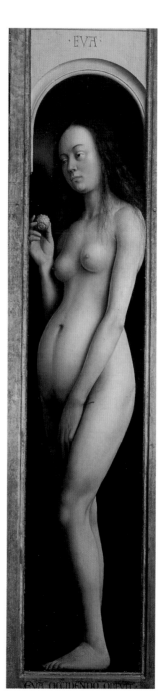

New York Diptych, Crucifixion

c. 1425

Oil on panel transferred to canvas, 56.5 x 19.7 cm
Metropolitan Museum of Art, New York

Once attributed to Petrus Christus or an anonymous artist, this small diptych is now considered to be the work of van Eyck. The two panels having at one stage been separated, there has been some conjecture that there may have been a third panel, perhaps an Adoration of the Magi, in the center. The quality of the painting is exceptional. In the *Crucifixion,* he skillfully adapts to the oblong format required by the *Last Judgment,* and instead of the usual left to right reading, the narrative is conceived in a succession of horizontal planes from the bottom to the top, finally leading the eye towards an extraordinary and atmospheric landscape receding far away into the distance. The narrative is bursting with different figures and events, all of which are occurring simultaneously: as Christ's side is pierced by the spear, his mother faints into the arms of John and a group of women, and Mary Magdalene falls to her knees with clasped hands, distraught. The sense of realism created by such attention to detail is further echoed in the figure of Christ, which has been painted naturally and without idealization. It serves as a reminder that he is God made Flesh, a human being dying an agonizing death on the Cross for the redemption of mankind.

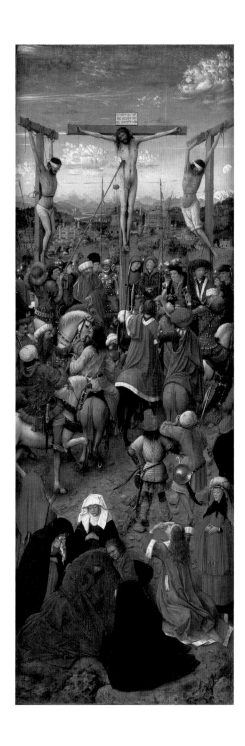

New York Diptych, Last Judgment

c. 1425

Oil on panel transferred to canvas, 56.5 x 19.7
Metropolitan Museum of Art, New York

Although sharing the same vertical rectangular shape as the _Crucifixion_, the direction of reading of the _Last Judgment_ goes from top to bottom, rather than vice versa. In an age-old artistic tradition, the eye of the viewer is lead through the stark choices awaiting the human spirit after death, from the celestial realms of heavenly joy down to the horrors of hell. In paradise, the elect are seated in an ordered array around the central figure of Christ, in the style of medieval iconography. The Archangel Michael stands in the center, while beneath him Death sends the damned catapulting into the waiting jaws of infernal monsters, in scenes reminiscent of passages from Dante. There is a clear demarcation between light and darkness, between the light of God and a darkness devoid of any of light whatsoever. Dante considered this absence of divine illumination to be the worst infernal penance of all. In the middle, a tiny earthly zone depicts the resurrection of the dead. The work is characterized by a large number of inscriptions, not only on the frame of the painting, as was traditional, but also within the painting itself, on the Archangel Michael's shield and garments, on Christ's robe, and on the wings of Death. From an intellectual point of view, this inclusion of numerous references indicates that the work was commissioned by someone of considerable intellect, matched by an artist capable of reflecting that intellect in his creation.

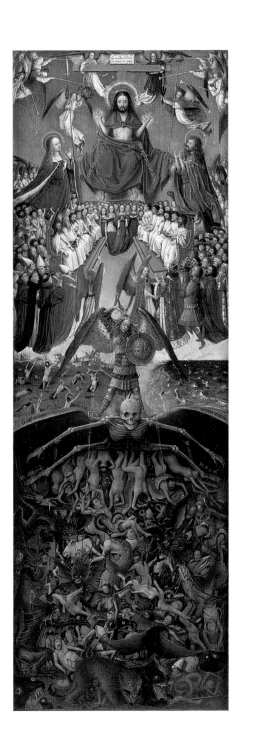

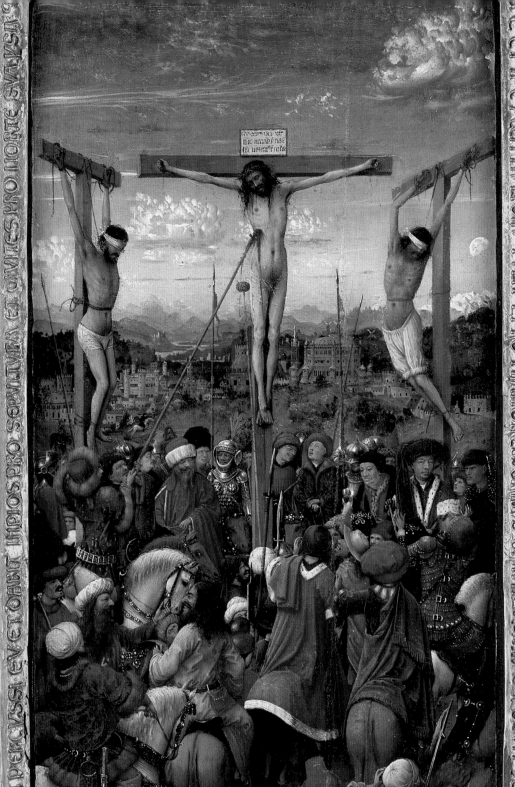

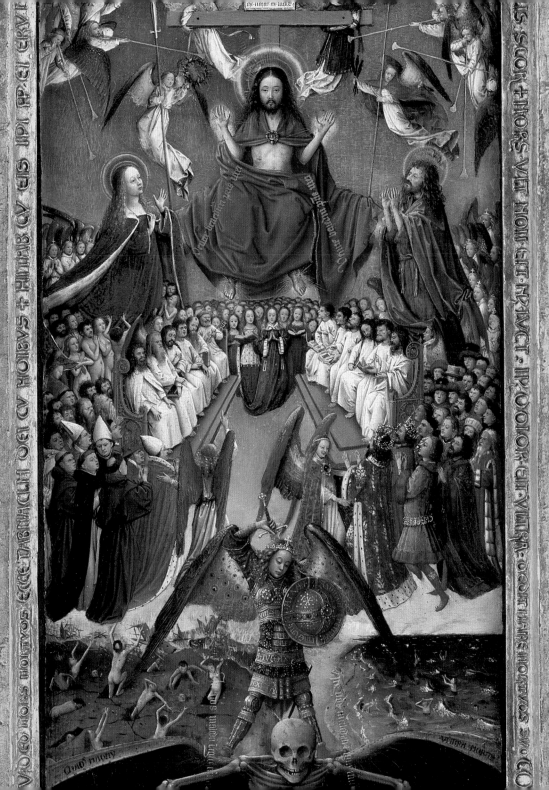

The Three Marys at the Tomb

c. 1426

Oil on panel, 71.5 x 90 cm
Museum Boijmans Van Beuningen, Rotterdam

This painting is one of the many ascribed to van Eyck's workshop whose authorship has been the subject of continual debate over the years. For some time it was considered to be the work of his older, less well-known brother, Hubert. In the twentieth century the art historian Erwin Panofsky argued that he could discern the hand of both brothers, and that this was most likely the product of a collaboration between the two. Others have attributed it to the hand of the great master alone. The work is intriguing not only in terms of authorship, but also in terms of composition. It is articulated by means of a series of diagonals: the woman and the angel, the position of the soldiers, the lid of the tomb, the rocky outcrop, and the cityscape in the background. These diagonal lines together create a rhomboid. The scene is observed with great attention to detail, to realism, and to the effects of light, the latter illustrated to striking effect on the gleaming armor of the sleeping soldier. The cityscape in the distance is not a fantastical one, for it bears a close topographical resemblance to the city of Jerusalem, a fact that seems to substantiate the hypothesis that van Eyck did indeed travel to the Holy Land. The presence of a few rays of light coming from the right of the painting has been argued by some, including Panofsky, to indicate the likelihood of a second adjoining panel, or even panels, possibly showing the Resurrection of Christ.

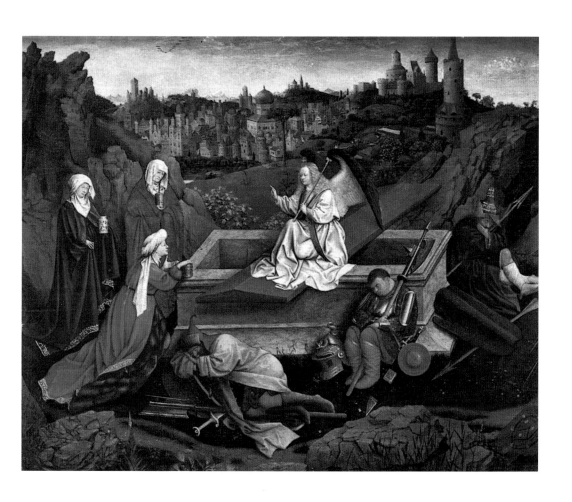

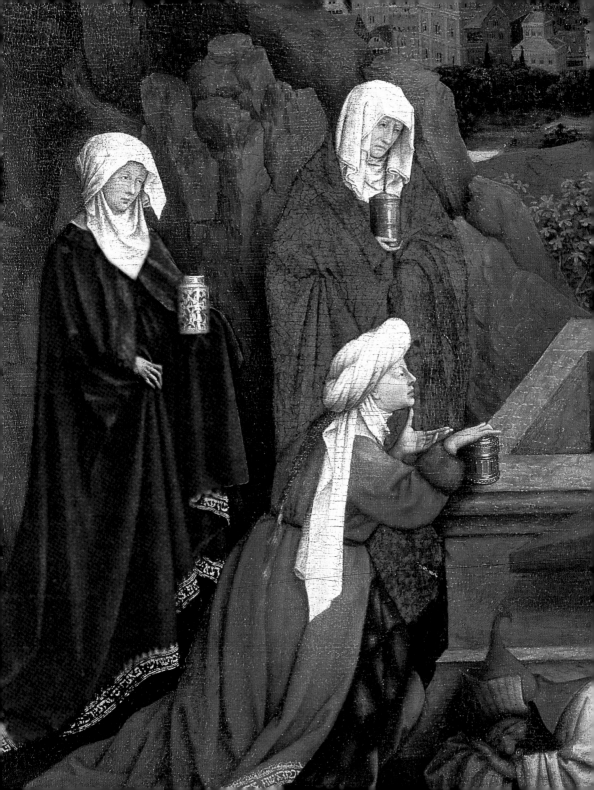

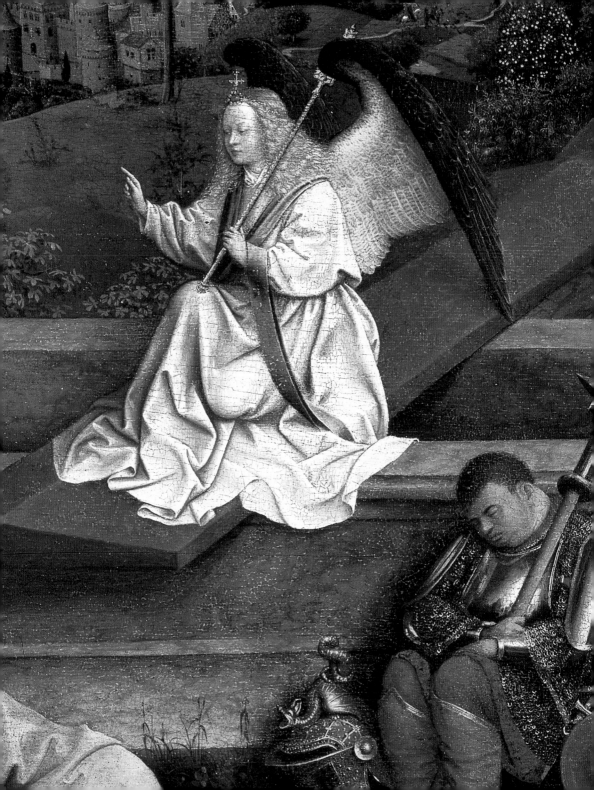

Madonna in a Church

c. 1426

Oil on panel, 31 x 14 cm
Gemäldegalerie, Berlin

This small, delicately painted work is laden with symbolism. The Virgin's size is disproportionate in relation to the church interior, and this emphasizes her symbolic identity with the building. Van Eyck is here presenting her as the *Mater ecclesiae*: she is not the Madonna in a church but the Madonna who embodies the Church. Along the hem of her robe are embroidered in gold thread fragments of the Latin words *sole* (sun) and *luce* (light), words from the Office of the Assumption establishing her as Queen of Heaven. The celestial vision is confirmed by the presence of two singing angels seen at the far end of the church. The architecture is remarkable for its precision and verisimilitude. The interior of the Gothic church is flooded with light, which enters through the numerous windows. The light takes on a transcendental meaning in the presence of the Virgin, becoming imbued with a symbolic power as well as having a a compositional role. Van Eyck makes full use of spatial experiments, with the interior of the church expanding to the left and also to the far right of the painting. The slightly off-center position of the Virgin, and the direction of her gaze, suggest that this is likely to have been the left-hand wing of a devotional diptych.

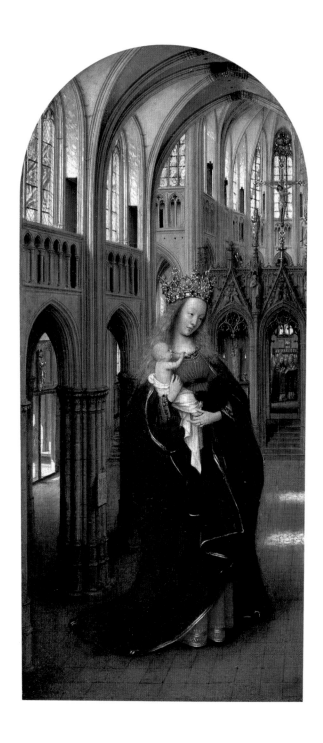

St Francis Receiving the Stigmata

c. 1428–1430

Oil on panel, 29.2 x 33.4 cm
Galleria Sabauda, Turin

This painting, which exists in several version, represents an important example of van Eyck's landscape painting. The figure of the saint receiving his stigmata, thus making him an *alter Christus,* is of secondary importance compared with the vast panorama that extends behind him. It is the first treatment of this subject in Netherlandish painting, and varies considerably from the previous version by Giotto. The painting's connections with Italy considerably pre-date the fact that it is now housed there, for early on it was owned by Anselmo Adorno, a rich and influential Genoese merchant who was a member of Philip the Good's court circle in Bruges. Anselmo had two copies of the painting made in 1470, which were to be bequeathed to his two daughters who had taken holy orders. The person who originally commissioned the work is unknown, Anselmo having been too young at the time. Once considered to be a later copy, the painting was subjected to an X-ray analysis that showed a clear and sophisticated design underneath the surface, which could only have been executed by the hand of the great Flemish master.

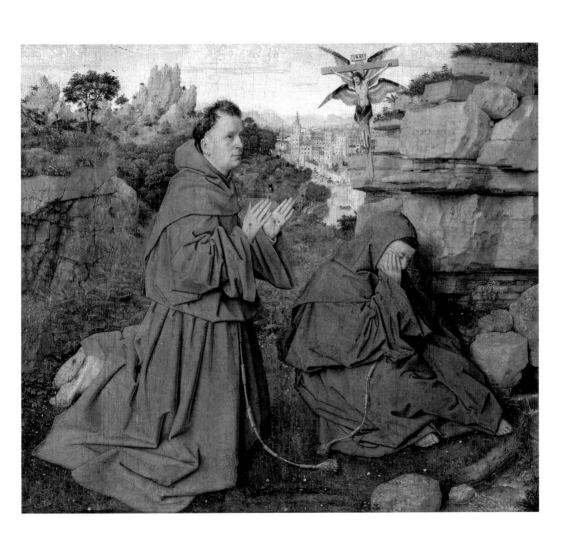

St Francis Receiving the Stigmata

c. 1428–1430

Oil on parchment on panel, 12.7 x 14.6 cm
Philadelphia Museum of Art, Philadelphia

Opinion remains divided as to the authorship of this panel, which is almost identical to its twin in Turin. Erwin Panofsky declared himself to be guilty of "flagrant heresy" when confessing his own doubts as to the attribution of the master, and favoring the attribution to his workshop. More recently, opinion has shifted in the opposite direction, particularly in the wake of an exhibition in 1997, which showed the two versions side by side. Close study and comparison revealed that, despite the differences in size, the two panels were almost identical, down to the tiniest details. This version is considerably smaller than the one in Turin, and van Eyck's skill as a miniaturist is much in evidence. It was concluded that the smaller panel was a replica of the larger one, and executed by the same hand, a fact confirmed by the fact that scientific analyses showed the complete absence of a preparatory sketch beneath the painted surface of the replica. Perhaps the issue of authorship has now been resolved, but there still remains a degree of mystery surrounding this pair of paintings. Little is known about their history, apart from the fact that the Turin version was owned by Anselmo Adorno in the fifteenth century. No one knows as yet who commissioned the work, for what purpose, and why two versions were painted. Nonetheless, the paintings were important prototypes for the future artistic treatment of the scene, such as those painted much later by Caravaggio.

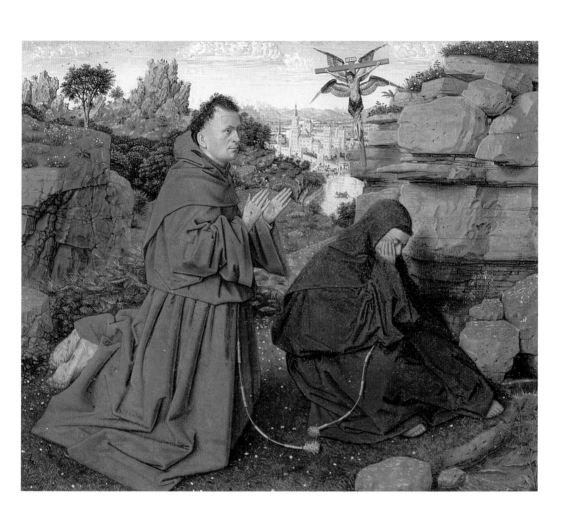

Portrait of a Man with a Blue Chaperon

c. 1429

Oil on panel, 22.5 x 16.6 cm
Muzeul National de Arta al României, Bucharest

Despite its poor state of conservation, this painting is clearly of the high-est quality. It is thought to be van Eyck's earliest surviving portrait, and it was to have a considerable effect on the subsequent development of the art of portraiture. The portrait exemplifies his use of illusionism: the sit-ter is shown in a three-quarter-length pose, and set against a dark, shadowy background. His hand appears to be resting on a ledge, which would originally have coincided with the painted frame that is now no longer visible. In his right hand he holds up a ring, which gave rise to the earlier assumption that this was a portrait of a goldsmith, like his *Portrait of Jan de Leeuw* housed in Vienna. Today it is thought more likely that the work represents a type of painting used to propose a marriage. There is no attempt at idealization here: the stubble of the man's beard is painted with painstaking precision, likewise the pointed nose, and the eyebrows arching over the eyes, with their slightly vacuous expression. The direction of light entering from the left enhances the contrasts between light and shadow. In 2006 the portrait was included in an exhi-bition dedicated to Antonello da Messina, which was mounted in Rome. It was chosen as an example of the luminosity of Flemish painting, which strongly influenced Antonello, and which he then combined with the plasticity of the Italian artists. Light was as important to van Eyck as perspective was to artists of the Italian Renaissance. Visible in the upper left corner of the portrait is a feigned monogram of Albrecht Dürer, dated 1492, which was added in the eighteenth century.

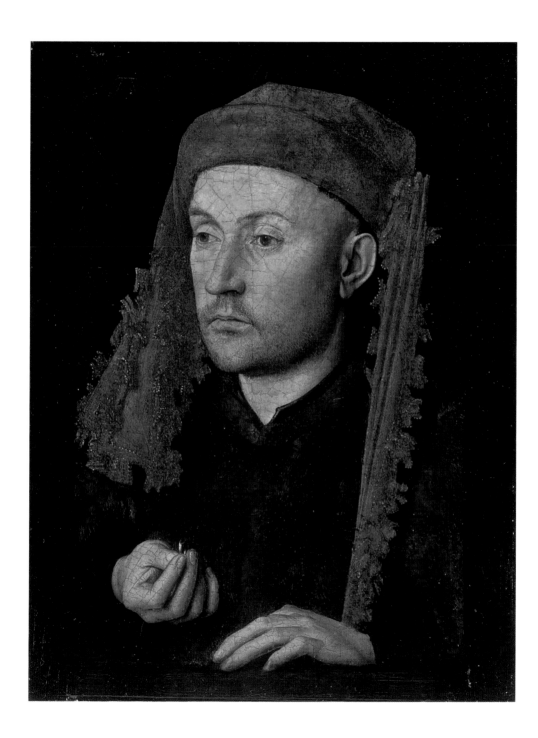

Portrait Drawing of Cardinal Niccolò Albergati

c. 1431

Silverpoint on paper prepared with white chalk, 2.4 x 18 cm
Kupferstich-Kabinett, Staatliche Kunstsammlungen, Dresden

This striking sketch is one of the few works out of his entire oeuvre
that van Eyck actually signed. It was probably made during one of the
Cardinal's trips to Bruges, towards the end of 1431. He sketched the
portrait, which captured the essential features of the Cardinal, in a mat-
ter of a few days (8–11 December). A few years later, using his drawing
and notes as a guide, he executed the portrait in in oils (p. 119), without
making a preparatory sketch on the panel. This was an acceptable prac-
tice in artistic circles, and was later used by Albrecht Dürer for his
engraving of Erasmus of Rotterdam, whom he had sketched six years
previously. Van Eyck's drawing is remarkable not only for its confidence
and spontaneity, but also as a glimpse into the thought processes of the
artist himself. He made autographed notes as to how the portrait should
progress, and on the drawing itself he made precise notes on the colors
he would use: yellowish, bluish white, whitish lips, reddish nose.

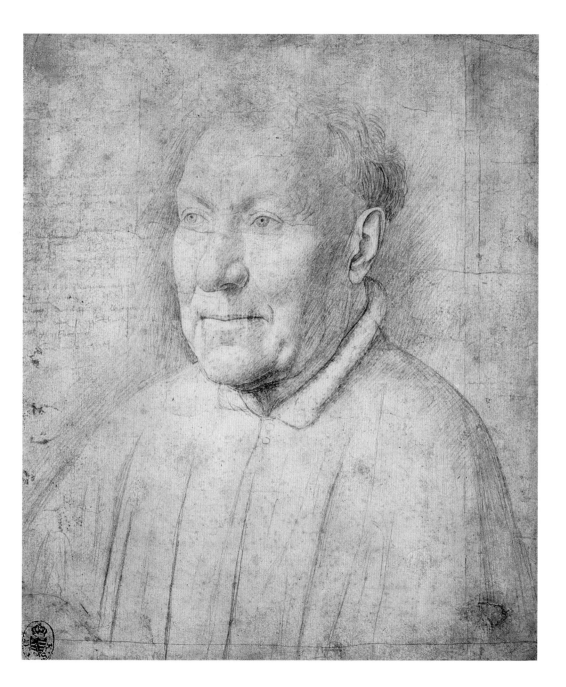

Portrait of a Man (Léal Souvenir)

1432

Oil on panel, 34.5 x 19 cm
National Gallery, London

Together with the *Ghent Altarpiece,* which was completed in the same year, this was the first work to be signed and dated by van Eyck. In a notable example of trompe-l'oeil, the man stands behind a cracked parapet painted to resemble weathered stone, upon which the artist's signature is carved. The foreshortening of the right hand to create a sense of perspective is executed with boldness, a device later used to great effect by Antonello da Messina. The face of the sitter is impressively naturalistic, its contours and details, set against a dark background, highlighted by the light coming from the left. Panofsky, who has made a particularly thorough study of the painting, identifies it as being unique within the catalogue of the artist, and within Northern art of the fifteenth century as a whole. It is the only one of van Eyck's paintings to include an inscription in French ("Léal souvenir," faithful souvenir), and the only one to contain a classical allusion. The Greek inscription on the parapet translates as "Tymotheos," a name that calls to mind Timotheus of Miletus, the famous Greek musician and lyric poet, so the allusion amounts to an evocation of a personage of such stature as Alexander the Great, or Scipione. It could well be concluded that the sitter was a man of distinction at the court of Philip the Good, perhaps himself a musician. Panofsky goes so far as to suggest a name: Gilles de Binchois. By giving him the name "Tymotheos," van Eyck is referring back to antiquity in the manner of his epoch; appellations such a "new Apollo" or a "new Zeus" were very much in vogue.

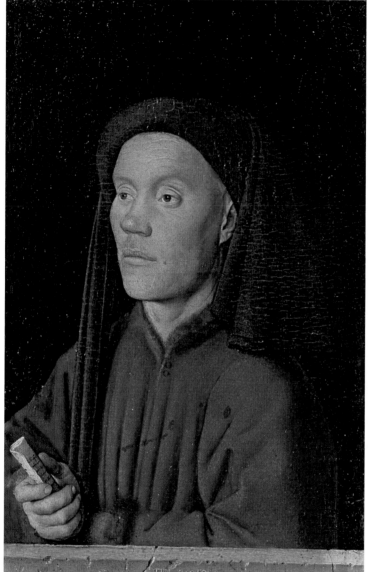

Portrait of Baudouin de Lannoy

c. 1432

Oil on panel, 26 x 19.5 cm
Gemäldegalerie, Berlin

Despite his nickname "the Stammerer," Baudouin de Lannoy enjoyed an elevated social position: he was Governor of Lille and chamberlain in the court of Philip the Good. He is shown here with the insignia of the Order of the Golden Fleece. It is certain that van Eyck would have known him, for they both took part in the diplomatic mission to Portugal in 1428, the aim of which was to secure the marriage of Philip to the Infanta Isabella. The portrait shows him as a powerful court official, dressed in the large fur hat worn on ceremonial occasions, and gripping a military staff in a determined fashion. He is wearing a sumptuous brocade cloak, embellished with fur at the collar and cuffs. The insignia of the fleece hanging from a gold chain was bestowed upon him in 1431, which helps to give the painting an approximate date. He is portrayed as a determined, ruthless, cold character; an accurate rendition devoid of idealization. His concrete, fearsome physical presence is rendered more powerful by the lack of any background detail as he looms out of the darkness. Stylistically speaking, the portrait resembles the *Portrait of a Man (Léal Souvenir)*: both figures are shown half-length, and in a similar pose. However, van Eyck never resorted to prototypes or repetition in his paintings—each one was conceived afresh, and he was capable of infinite variations, a skill in tune with the precepts of the Italian Renaissance, which praised the concept of *varietà* (variety) in art.

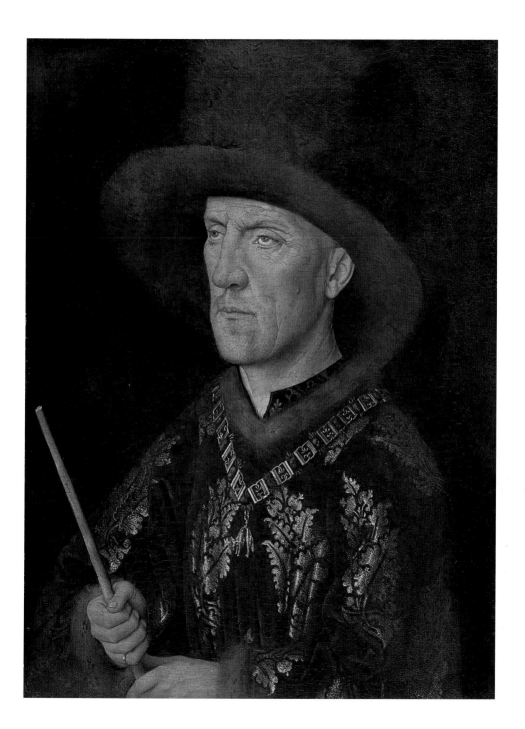

Man in a Turban

1433

Oil on panel, 25.5 x 19 cm
National Gallery, London

The subject of this painting, which has often been considered a self-por-
trait of the artist, fixes his gaze steadily on the onlooker, who thereby
becomes an integral part of the painting. This was one of the tenets of
Renaissance painting: the public was no longer peripheral to the work
of art, but a vital component in bringing it to fruition. There is a painted
inscription at the bottom of the frame stating that it was painted by van
Eyck in 1433. Along the top of the frame is the phrase "Als ich kann"
(As I can), which can be interpreted as a token of modesty, or even per-
haps of pride in his own capabilities. Van Eyck was well aware of his
skills as an artist, and made no secret of the fact. The red turban is a
work of virtuosity, its pleats and folds magnificently observed and real-
ized. Instead of being assigned a marginal role, as would be usual, the
turban forms a dominant feature in the painting, helping to concentrate
the gaze on the real focal point, which is the subject's face. The face is
further accentuated by the absence of the hands, an omission repeated
only in the portrait of Cardinal Albergati. There is an emphasized con-
trast between the luminosity of the face and the darkness of the back-
ground and the clothes. The absence of hands has also fuelled specula-
tion that the artist painted himself in a mirror, and that this is indeed a
self-portrait. The impact, intensity and composition of the painting are
highly likely to have influenced Antonello da Messina's *Portrait of a Young
Man*, which hangs in the same gallery in London.

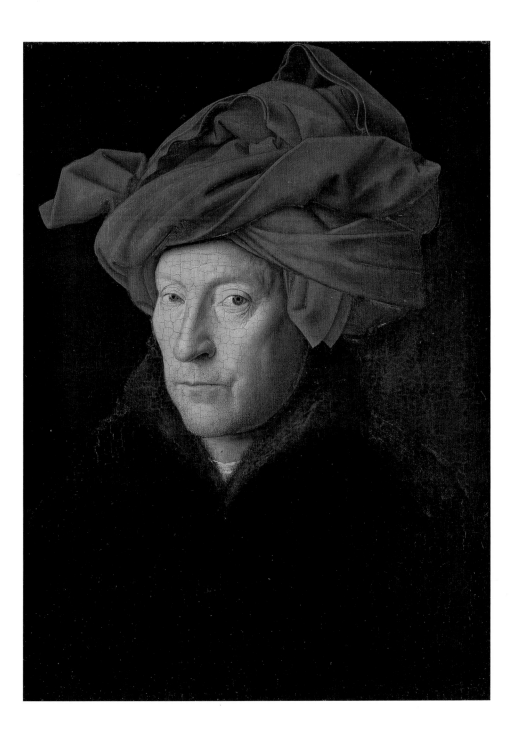

The Annunciation

c. 1433–1435

Oil on canvas, transferred from panel, 92.7 x 36.7
National Gallery of Art, Washington

This Annunciation scene, probably commissioned by Philip the Good, does not take place in the Virgin's home, as described in the Gospels, but in a medieval church. The fictitious interior is composed of a synthesis of Romanesque and Gothic styles. North of the Alps, the Gothic style was less markedly pointed than elsewhere, so that the lower Gothic arcades are not so very different to the Romanesque windows of the upper level. The windows are Gothic, but there is no evidence of the traditional Gothic supporting structures and ribbed cross vaulting in the roof over the central nave. Instead, the coffered ceiling is more reminiscent of a basilica. Scenes from the Old Testament are illustrated on the tiles of the floor in Flemish style. The decorative effect is completed by the ornate brocade of the angel's robe, embellished with jewels, and its colorful wings. Van Eyck's attention to detail is evident in the three windows behind the Virgin, and the carved capitals of the columns. The artist never worked to any set formulas of composition, but preferred to play with a variety of devices. Here, the convergence of architectural lines leading to the vanishing point is broken up by the positioning of the figures, which in turn guide the eye along a diagonal line, this time towards the right.

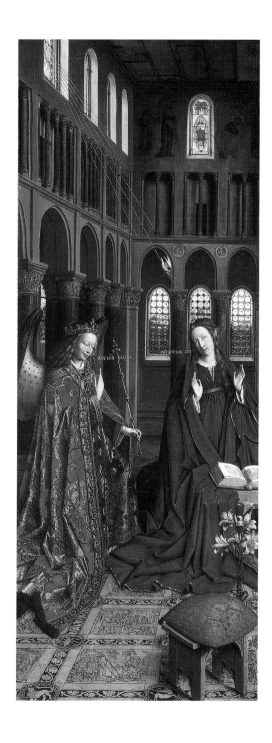

The Arnolfini Marriage

1434

Oil on panel, 81.8 x 59.7
National Gallery, London

This painting represents the pinnacle of fifteenth-century bourgeois painting. The scene takes place within a bedchamber, and shows a wealthy gentleman offering his hand in marriage to a noble lady. The characters are thought to be the prosperous Italian merchant Giovanni Arnolfini and Giovanna Cenami, daughter of a rich banker. Although originally interpreted as the occasion of the marriage, recent studies have suggested that it is a betrothal, for there is no evidence of a ring, nor are the two right hands joined. Quite apart from the central couple, the painting represents a complex enigma. What might otherwise have been a simple portrait is imbued with a solemn, almost religious atmosphere that seems to go beyond the celebration of a matrimony. Even mundane, prosaic objects seem to take on a spiritual significance. In fact, the painting is laden with symbolism: the little dog is a symbol of fidelity, and in the case of a widower it represented continued faithfulness to the departed woman; the couple's hands are joined in a symbolic gesture; the single candle lit in the candelabra symbolizes Christ; the fruit on the table by the window represent innocence, and the mirror hanging on the wall the virginal purity of the woman (*speculum sine macula*, "mirror without blemish"). The signature of the artist ("Johannes de Eyck fuit hic 1434") on the wall above the mirror is like the signature of a witness to a marriage. The scene is clearly much more than a bourgeois interior. In the hands of van Eyck it has become a sacred place, and the nuptial bed a place of consecration.

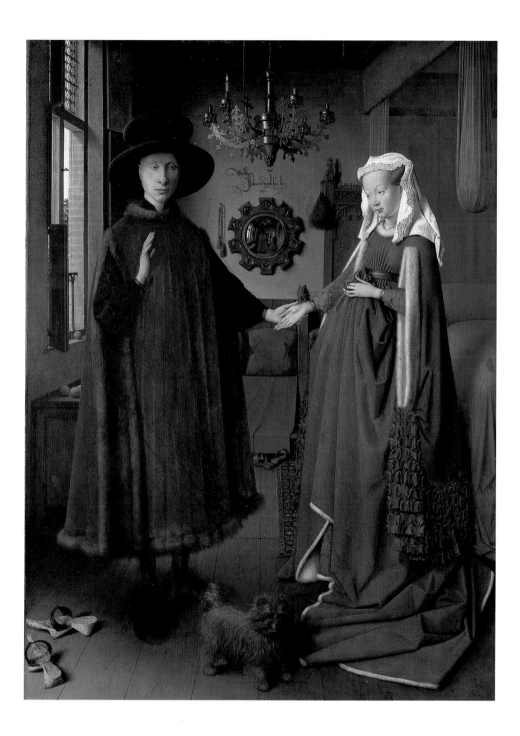

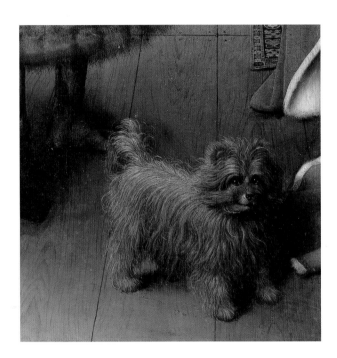

*The Arnolfini Marriage
(details)*

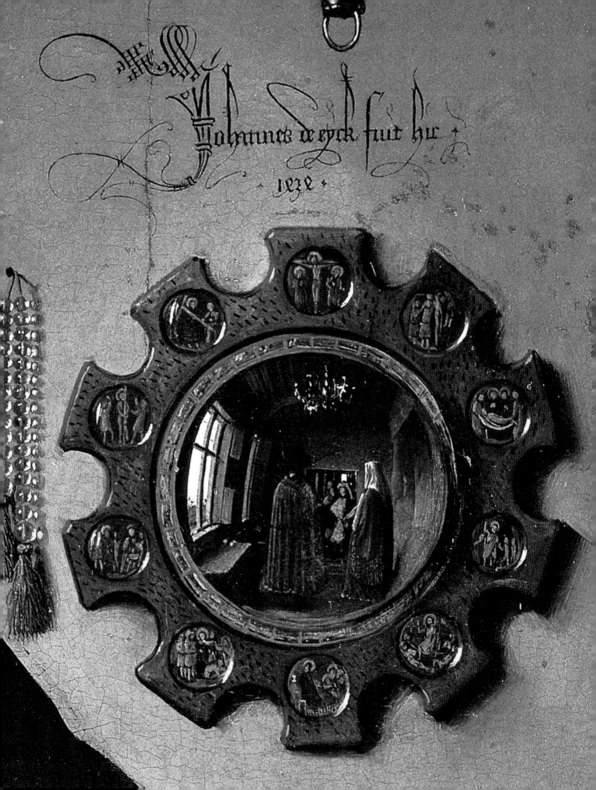

Madonna of Chancellor Nicolas Rolin

1434–1435

Oil on panel, 65 x 62.3 cm
Musée du Louvre, Paris

This painting was originally commissioned by Nicolas Rolin for his private family chapel in the cathedral in Autun, the birthplace of the donor in 1376. Rolin was a trusted advisor to Philip the Good, and in 1422 he was appointed Chancellor of Burgundy and Brabante. He became one of the most important charitable patrons of his day, also commissioning a polyptych from Rogier van der Weyden for the hospital in Beaune. Its size and composition suggest that it was intended for the private devotions of the donor: unusually, the Virgin is placed to one side rather than centrally, and the figure of the donor seems somewhat presumptuously to be equal in size to that of the Virgin, who was normally portrayed disproportionally larger in order to symbolize her spiritual importance. The perspective depth of the interior is defined by the floor tiles decreasing in size, and beyond the archway there lies an enclosed garden, and a distant landscape. The work ranks amongst the most impressive examples of Early Netherlandish landscape painting, and was also significant in the evolution of the donor portrait. For both these reasons it is one of the most important paintings in van Eyck's oeuvre. The effects of light are also a dominant feature of the painting: reflected on the windows, the polished tiles, the surface of the river, and the distant glow of the horizon. It played an influential role in the development of the luminous style of later Italian artists such as Piero della Francesca and Domenico Ghirlandaio. The legacy of van Eyck was to affect the course of art history for many decades to come.

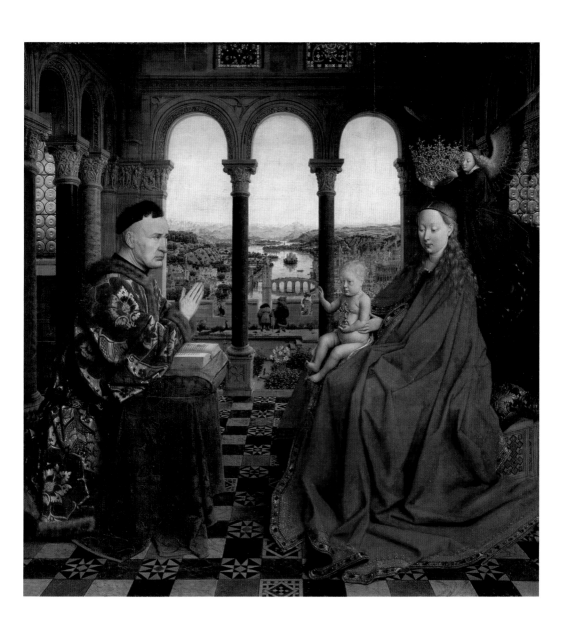

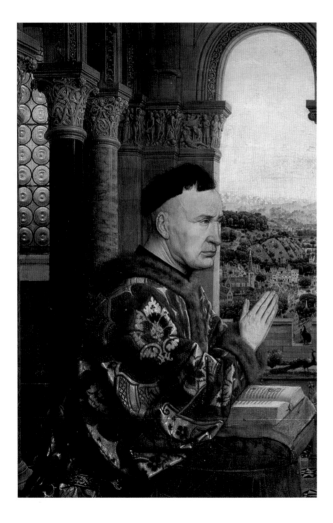

Madonna of
Chancellor Nicolas
Rolin (details)

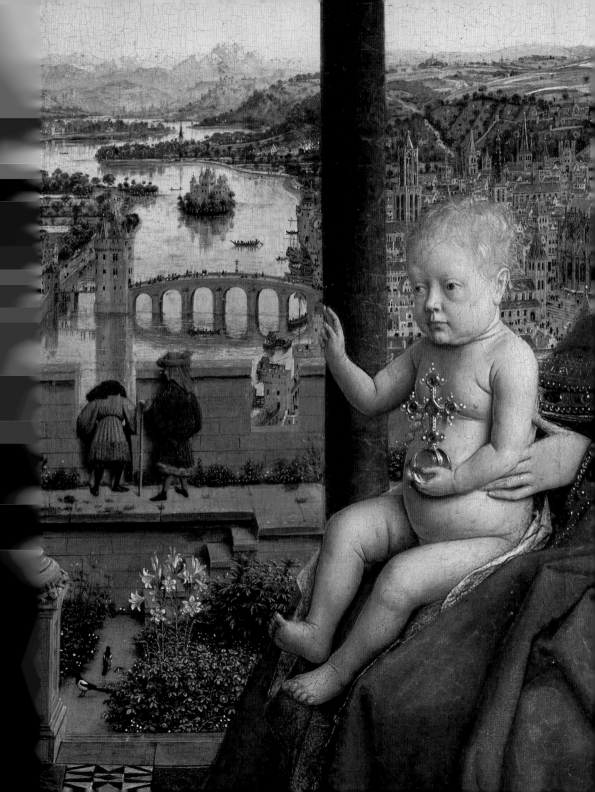

Madonna of Joris van der Paele

1436

Oil on panel, 141 x 176.5 cm
Groeningemuseum, Bruges

The inscription on the bottom of the frame identifies the donor, the
artist, and the year of execution of the painting: Joris van der Paele,
canon of the church of St Donation in Bruges, had the work made by Jan
van Eyck in 1436. The personages involved in this *sacra conversazione* are
the patron saint of the church, St Donation, on the left, the Virgin and
Child in the center, and, on the right, the donor with his patron saint,
St George. The donor is painted with unflattering realism, and he may
well have already been suffering from the illness that was to result in his
death a few years later. In keeping with the traditional iconography, the
donor is being presented to the Virgin by his patron saint. The social sta-
tus of the donor is reflected in the richness of the decorative scene. The
robes are ornate and embellished with jewels, the carpet is covered with
geometric patterns, and the capitals of the columns are intricately
carved. The work was conceived on a larger scale than was usual for van
Eyck, and his figures appear monumental in their voluminous robes. His
style of oil painting was much bolder than the delicate International
Gothic style, facilitating a sense of space and solidity. The Virgin and
Child turn towards the donor and receive him with a benevolent expres-
sion. St George is clad in a magnificent suit of armor that reflects the
light. In the shield carried over his shoulder there is a small reflection
of a man in bourgeois attire, quite probably the artist himself. This has
given rise to the idea that there might be a double allusion here: the
inscription above the Virgin refers to her as being "without blemish,"
so perhaps the artist is making the same claim about his painting.

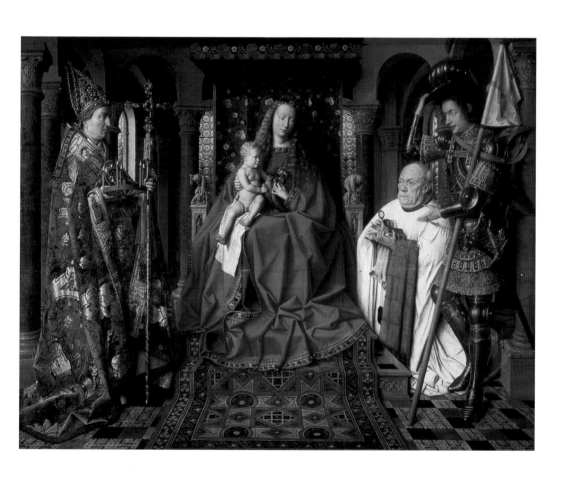

Madonna of Joris van der Paele (details)

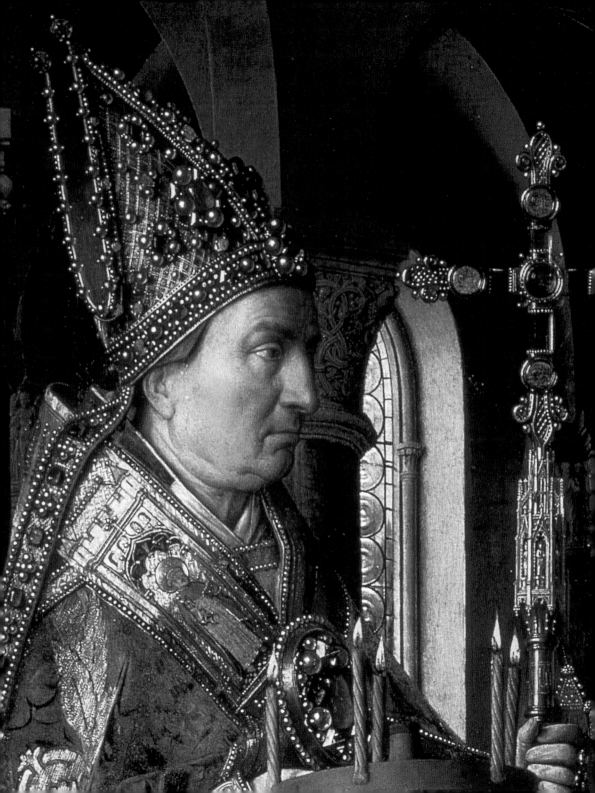

Portrait of Jan de Leeuw

1436

Oil on panel, 24.5 x 19 cm
Kunsthistorisches Museum, Vienna

Along the edge of the outer frame runs an inscription written in Flemish, unusually written in the first person: "Jan de [Leeuw], who first opened his eyes on the Feast of St Ursula, 1401. Now Jan van Eyck has painted me, you can see when he began it. 1436." The inscription seems to affirm the verisimilitude of the portrait, and the artist's pride in his creation. In the foreground, the man holds up a ring with his right hand, a symbol of his profession. For once the subject was not a member of court circles, but a member of the bourgeoisie, a wealthy goldsmith and prominent figure in his local guild. From a typological perspective, the painting belongs to a series of portraits where the subject fixes his gaze upon the viewer, as if initiating a dialogue. Unlike in previous works, this half-length portrait fills its frame, emphasizing the monumentality and plasticity of the figure, and no attempt is made to portray spatial depth behind him. Instead, van Eyck uses the play of light to create a sense of illusionism; he also uses the frame to create a sense of depth, with the left arm resting within the pictorial frame and the right hand seeming to protrude from it. Despite a relatively poor state of preservation that has marred some of the finer details, the painting remains one of the most striking of van Eyck's portraits, and one that was sure to have influenced the future works of Antonello da Messina.

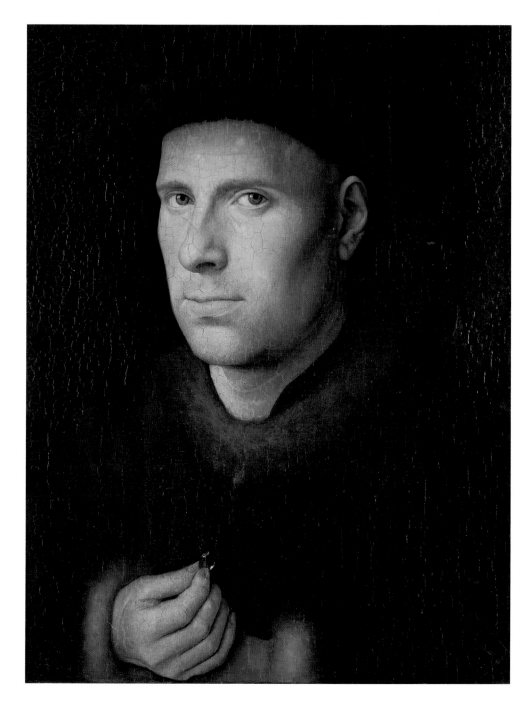

Triptych of the Virgin and Child

1437

Oil on panel, 33.1 x 27.5 cm (central panel), 33.1 x 13.6 cm (wings)
Gemäldegalerie, Dresden

Although the precise identity of the person who commissioned this trip-
tych is unknown, the inscription on the frame showing the date and
authorship of the painting also includes the coat of arms belonging to
the Giustiniani family, wealthy Genoese merchants who had established
a presence in Flanders. It is possible that the work was commissioned in
Bruges and then sent to the Ligurian capital, where it is known to have
subsequently influenced local artists. The donor, who seems likely to
have been Michele Giustiniani, is depicted in the left wing of the triptych,
kneeling in front of his namesake, St Michael, who is presenting him to
the Virgin. The painting bears a strong resemblance to another triptych
van Eyck painted for a different Genoese merchant, Giambattista
Lomellini. The artist was well known in Italy, his works circulating
throughout the country. Given its tiny dimensions, the triptych probably
served as a traveling altarpiece for use in the donor's private devotions
whilst on a journey. The right wing depicts St Catherine of Alexandria,
who is shown with the instruments of her martyrdom, the wheel and the
sword. The interior of the church is remarkable in its detailed realism:
the rows of arches are supported by columns of different colored mar-
ble, and surmounted by statues; the opulent brocade of the baldachin
is suspended on guy-ropes. There is an interesting contrast between
the figures on opposite wings: the donor is portrayed wearing contem-
porary clothing and with a fashionable hairstyle, whilst the figure of
St Catherine harks back to an earlier period, with a delicacy and subtlety
of form more in keeping with the style of the "autumn of the medieval"
than the vigorous plasticity of the Italian Renaissance.

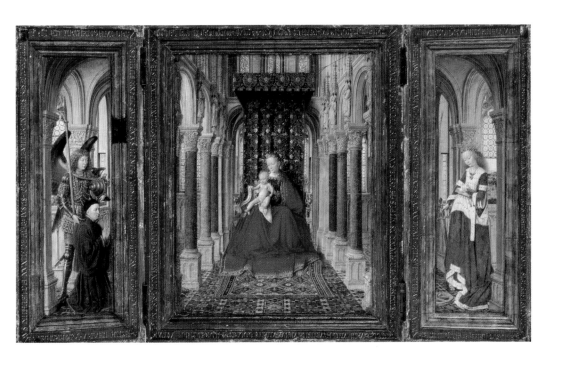

Triptych of the Virgin and Child, central panel

1437

Oil on panel, 33.1 x 27.5 cm
Gemäldegalerie, Dresden

With its wealth of detail, this tiny central panel of the *Dresden Triptych* is typical of the genre of small works painted on an easel that was much in evidence during the Northern Renaissance. It was a genre of paintings of small format, easily portable, created for donors and connoisseurs alike. In Italy the vogue was still for much larger-scale, grandiose paintings or frescoes to adorn churches or noble palaces. The success of this genre can be attributed to the emergence of a new class of bourgeoisie, an affluent middle class eager to flaunt its wealth by accumulating luxury items such as works of art. There was also a desire to emulate the nobility, whose prerogative it had been up until then to commission works of art. These smaller paintings came in a variety of forms, but portable altarpieces such as this one were popular for use in private devotions. The central panel shown here shows a luminous and opulent ecclesiastical interior that is both solemn and magnificent. It is a work of satisfying compositional symmetry, with the Virgin enthroned in the center. The sense of perspective is accentuated by three elements converging on a vanishing point behind the baldachin: the lines of columns and their upper row of statues, the inlaid marble floor, and the carpet woven in geometric designs, all of which guide the eye towards the spiritual and spatial center of the painting.

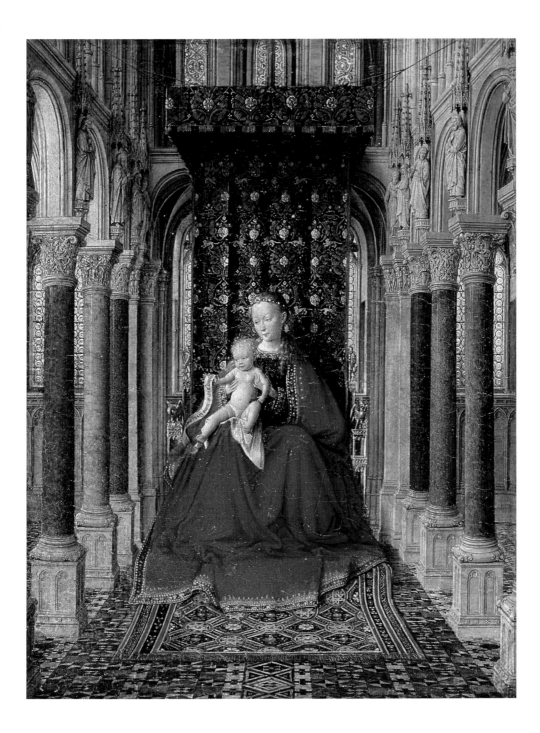

Triptych of the Virgin and Child
The Annunciation, outer wings closed

1437

Oil on panel
Gemäldegalerie, Dresden

The closed outer wings of this tiny triptych, the only one known to exist
in van Eyck's oeuvre, show the Annunciation. The Angel and the Virgin
are depicted in *grisaille* as imitation statues on pedestals and within
niches. The scene is almost identical to his *Diptych of the Annunciation*
in the Museo Thyssen-Bornemisza, Madrid. In this inventive exploration
of depth, substance and light, van Eyck seems to be making another
statement in favor of the supremacy of painting over sculpture, a debate
that continued throughout the Renaissance. The articulation of space
adheres to Alberti's principles (*De Pictura*, 1435), which ordained the use
of a frame to establish a sense of proportion and depth. The frame
serves a double purpose here, for it also simulates the structure of a
niche, where traditionally a statue would be placed. The three-dimen-
sional effect is heightened by the painted pedestals, which serve not only
to raise the statues, but also to emphasize the sense of being visible
from all sides, an effect which the sculptures of Donatello introduced
into the Italian Renaissance. The sculptural nature of the figures is
accentuated by the impression of light modulating their contours and
casting shadows behind the figures. The dove on the right-hand panel
also stresses the sense of spatial depth. The monochrome effect is the
result of a virtuoso technique that corresponds to another of Alberti's
tenets, that effects of light must be created using the most subtle grada-
tions in tone, and an extremely limited palate of colors.

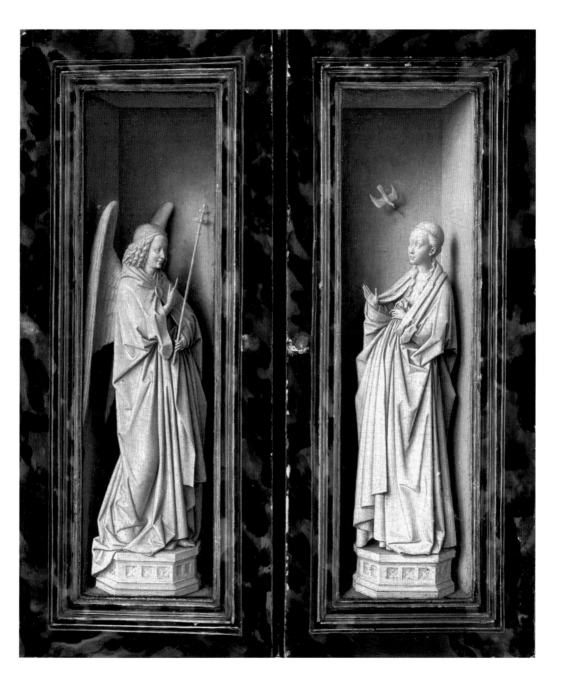

St Barbara

1437

Drawing and watercolor on panel, 31 x 18 cm
Koninklijk Museum voor Schone Kunsten, Antwerp

This work is something of an enigma in van Eyck's oeuvre and the con-
temporary artistic scene. Opinion has always been divided as to whether
it constitutes an underdrawing, a completed work, or an unfinished
work. The original frame in faux marble is signed and dated by the artist,
which might seem to suggest a finished work, though sometimes the
name was painted on the frame before the work was even begun.
Whatever the truth may be, it is clear that this painting represents a
departure from the norm for the artist. Here he is narrating a scene on
several different levels. The solid medieval tower behind St Barbara,
whose architecture resembles that of Cologne Cathedral, might be an
allusion to the legend that the saint's father had her imprisoned in a
tower following her conversion. The tower itself is still under construc-
tion, and the whole building site is bustling with tiny figures engaged in
various tasks. There are all manner of people involved, from menial
laborers carrying blocks of stone, to lofty architects shouting instruc-
tions. One in particular is trying to make himself heard by the workman
on the top of the tower. With its detailed and complex array of small
scenes, the work seems to foreshadow the paintings of Pieter Bruegel
the Elder.

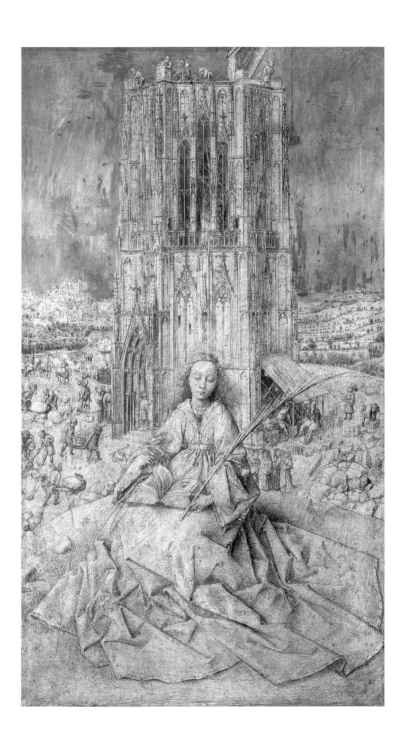

St Barbara
(details)

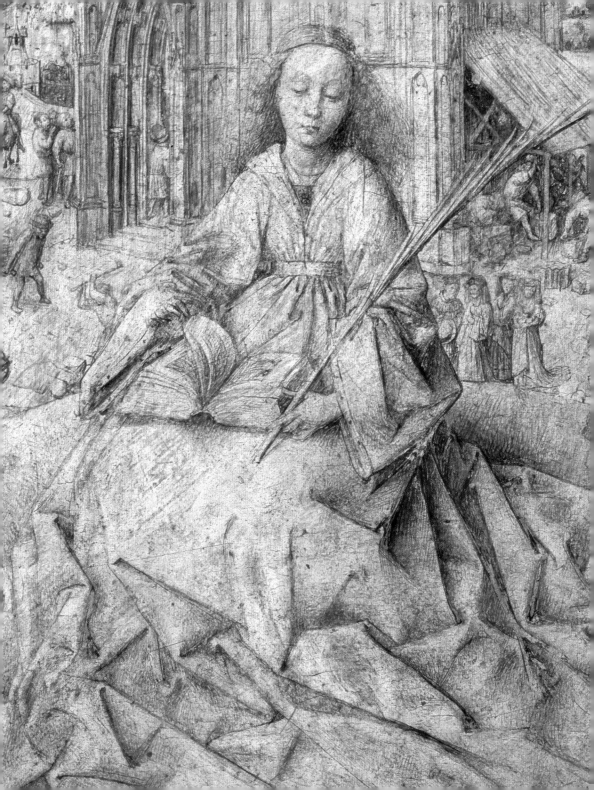

Lucca Madonna

c. 1437

Oil on panel, 65.7 x 49.6 cm
Städelsches Kunstinstitut, Frankfurt am Main

The painting takes its name from its first documented owner, Karl
Ludwig of Bourbon, who was Duke of Lucca until 1847. It is not known
who commissioned the work. The scene represents a perfect fusion of
the natural and the symbolic, of familial domesticity and religious
solemnity. The simple interior is adorned with touches of grandeur:
the Virgin is seated under a sumptuous brocade baldachin, her robe is
embroidered with jewels, and an ornately woven carpet rests beneath
her feet.

The lions flanking her on either side of the throne identify it as the
throne of King Solomon, who like David was considered to be a prefigu-
ration of Christ. The Virgin's face appears natural and spontaneous, to
the extent that it is said to have been modeled on that of the artist's wife,
Margarete. Unlike some of van Eyck's more lavish and ornate interiors,
this one retains a sense of sobriety and simplicity. The painting is char-
acterized by a subtle compositional symmetry: the Virgin is placed cen-
trally, whilst the window on the left is perfectly balanced by the niche
with shelves on the opposite side. Other details add to the sense of sym-
metry: the line of the Christ Child's back runs along the vertical axis,
parallel to the sides of the baldachin, and perpendicular with the base of
the raised platform. The voluminous folds of the Virgin's robe create a
triangular, almost prism-like effect, making her figure seem even larger
within the small scene.

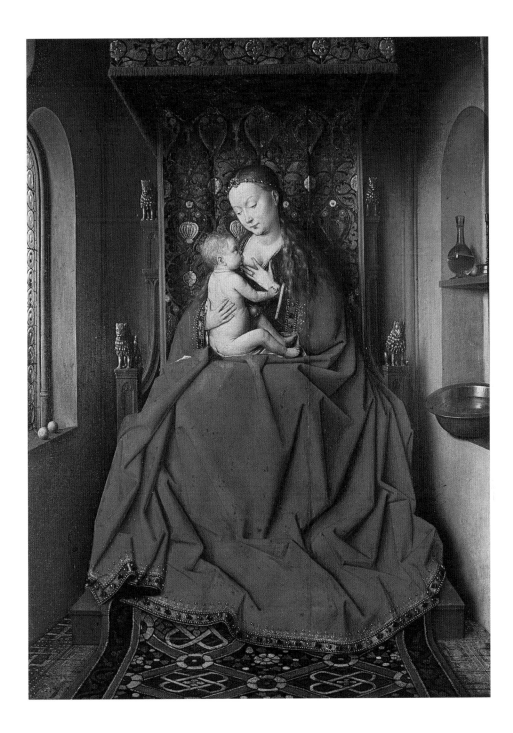

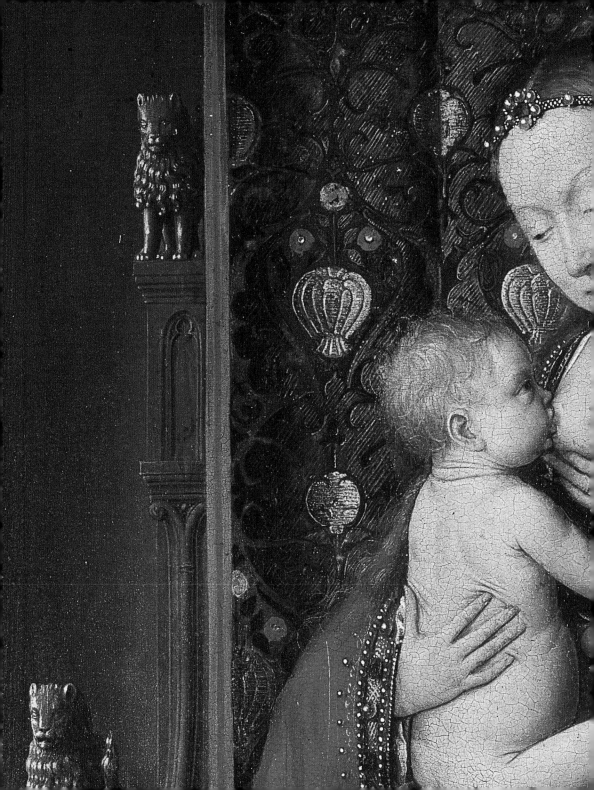

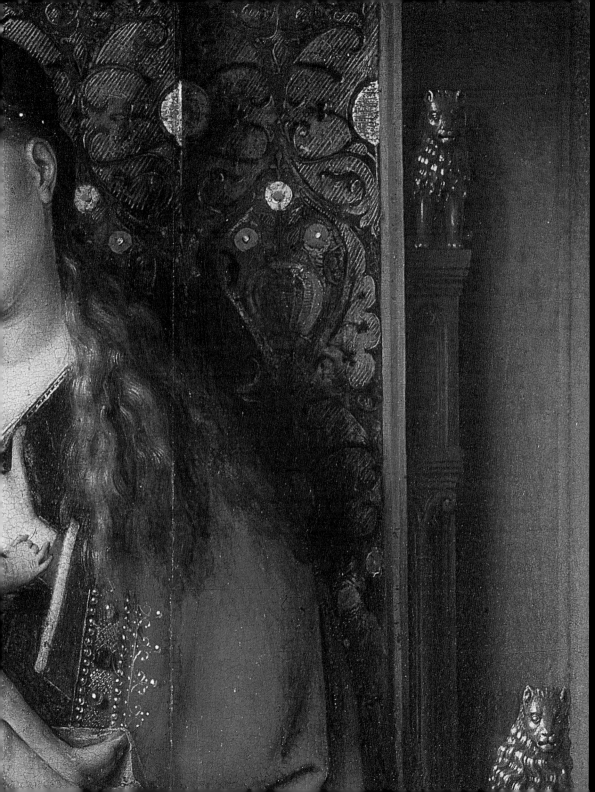

Portrait of Cardinal Niccolò Albergati

1435

Oil on panel, 34.1 x 27.3 cm
Kunsthistorisches Museum, Vienna

Niccolò Albergati, who was made a cardinal by Pope Martin V in 1426, was a powerful figure in papal circles. He served as papal ambassador in France between 1422 and 1431, and was sent as mediator to the peace congress held in Arras to effect a reconciliation between Philip the Good, Duke of Burgundy, and the French Dauphin, Charles VII. Van Eyck was also sent to the peace congress, presumably with the purpose of painting the portraits of the participants. This prestigious commission shows the extent of his international reputation by this stage. During the congress, van Eyck executed a preliminary sketch of the cardinal (p. 81), and the portrait is now thought to have been painted three or four years afterwards, in 1438. The sketch, drawn from life, is more vital and spontaneous, making greater use of shading, whereas the portrait represents a more considered approach. As was often the case, the finished work was as much about artistic technique as about authenticity, and in this instance, the cardinal's features have gained a certain intensity and gravitas. Despite the obvious difficulties of working without the model, the artist has added one or two slight indications of the passing of another few years to maintain a faithful likeness. Whilst not as detailed as the drawing, the painting succeeds in portraying the character of a powerful man with a concentrated gaze, detached from the mundane realities of life with a mind clearly focused on higher matters.

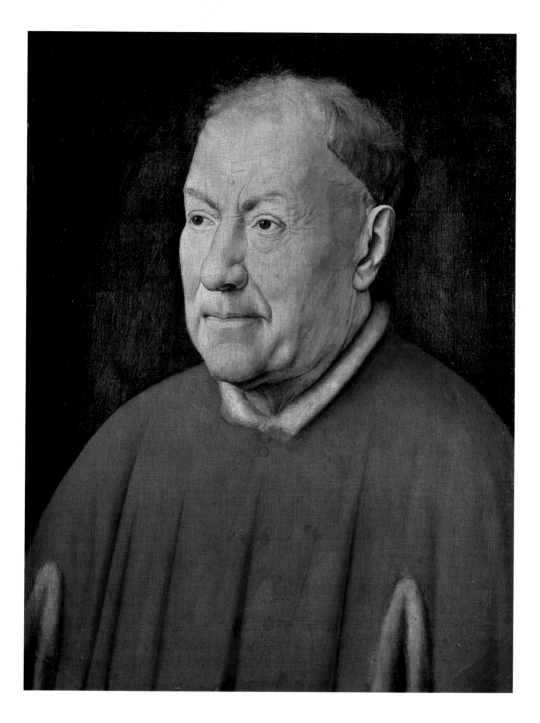

Portrait of Giovanni di Nicolao Arnolfini

c. 1438

Oil on panel, 29 x 20 cm
Gemäldegalerie, Berlin

This is second known portrait commission from van Eyck by the textile merchant from Lucca Giovanni Arnolfini. This fact raises a number of interesting considerations: under Philip the Good, trade flourished, which led to the emergence of a wealthy class of merchants such as Giovanni, who wanted to demonstrate their elevated social and economic status by having portraits made of themselves, in the manner of the nobility and the papacy. It also shows how the role of the artist was evolving: his domain was no longer limited to the court circles, for a new market had opened up with the emergence of a new middle class. The date of the painting, which was once considered to be a self-portrait, has oscillated between 1435 and the more probable date of 1438. As in many other instances, the original frame—now lost—would have contained the date of the work. Giovanni holds in his hands a piece of folded paper, which some scholars have suggested might be one of the international credit notes that had recently been introduced into the banking system by the Medici, and which were still something of a novelty. The crossed arms, which would have originally rested on the frame, form a solid base rather like the pedestal of a bust, which emphasizes the monumentality of the figure in a compositional form akin to the Italian style. The face is painted with subtle realism, the eyes rather small and the nose rather large, and his gaze is inscrutable, a psychological trait not uncommon in Flemish painting. In Panofsky's opinion, this is van Eyck's most accomplished male portrait. The figure is set at a slight angle to emphasize its monumentality, and the hands, an "eternal torment for all portraitists," are exquisitely rendered.

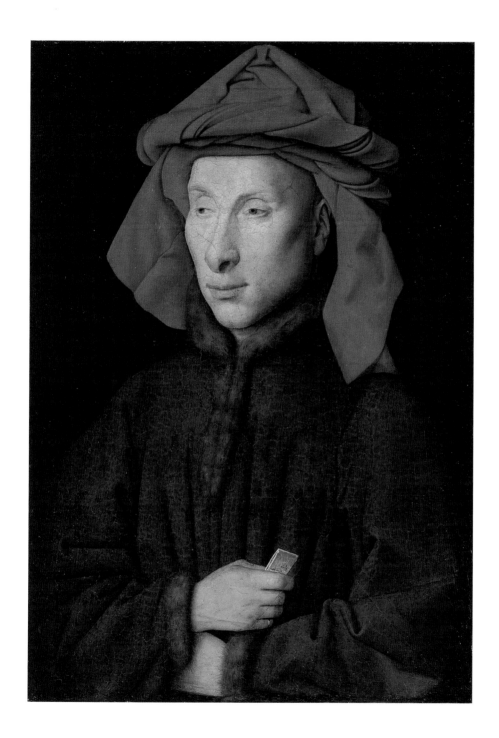

Madonna at the Fountain

1439

Oil on panel, 19 x 13.5 cm
Koninklijk Museum voor Schone Kunsten, Antwerp

This small devotional panel, signed and dated on the lower frame, is one of the last works attributed to van Eyck, who died two years later. Executed the same year, the *Madonna at the Fountain* and the *Portrait of Margarete van Eyck* are the last dated paintings by the master. The panel has been identified as one mentioned in an inventory of 1516, which suggests that it may have been in the collection belonging to Margaret of Austria, who was governor of the Low Countries. The image of the Virgin Mary was inspired by the Byzantine icon of the *Maria Eleusa*, the Virgin of Mercy. The tiny panel contains a wealth of symbolic imagery referring to the Mother of God and to her virginity: the enclosed rose garden behind alludes to the *hortus conclusus,* the heavenly garden of the Song of Songs; the fountain refers both to the Virgin as the *fons hortorum* ("garden fountain") of the Song of Songs, and also to the figure of Christ as the fountain of life. The minute dimensions of the panel seem to confirm that it would have been used for private devotions, and its popularity is attested by the several replicas of it which were made subsequently, well into the sixteenth century. Despite its size, the panel is one of van Eyck's most accomplished works, full of pictorial effects and the play of light, most notably in the reflections on the bronze fountain, the angels' wings, and the brocade drapery embroidered with gold that hangs behind the Virgin. This panel marks a shift in iconography from his other panels showing the Virgin and Child, for this time the bold red robes of previous versions has given way to the traditional blue, and she is also no longer portrayed in an interior, but in a garden full of allegorical motifs.

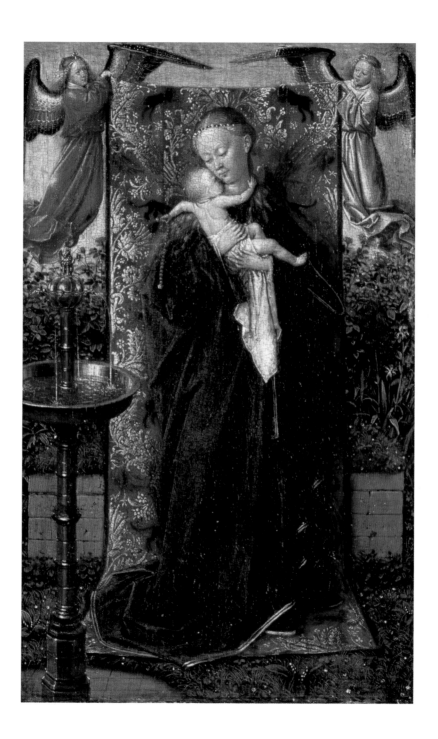

Portrait of Margarete van Eyck

1439

Oil on panel, 41.2 x 34.6 cm
Groeningemuseum, Bruges

As in many of van Eyck's paintings, the frame has an inscription; it reads: "My husband Jan painted me on 17 June 1439, at the age of thirty-three." Little is known about his wife Margarete, who gave birth to their first son in 1434, probably a few years after their marriage. Although her family background is not known, the fact that contemporary documents refer to her as "damoiselle Margherite" suggests that she may have been of noble birth. Her face is rendered with a naturalism that makes no concessions to idealization: she is not the most beautiful of women, but her steady gaze and pursed lips show her to be a resolute character. Her white headscarf is an extraordinary accomplishment, with layer upon layer of minute pleats rendered with intricate use of light and shade. It seems likely that this portrait would have been accompanied by a self-portrait of the artist, now sadly lost. It is the only (surviving) female portrait to have been painted by van Eyck, and the last one he ever did. The expression on the face of the woman seems to imply, as one would expect in this case, a certain familiarity with the painter. The composition of the portrait, with the face high up in the frame, seems to lend her a greater air of importance. As in his other portraits, the three-dimensional effect is accentuated through the use of chromatic and tonal contrasts: the pale face set against a dark background, and the red robe set against the white headscarf.

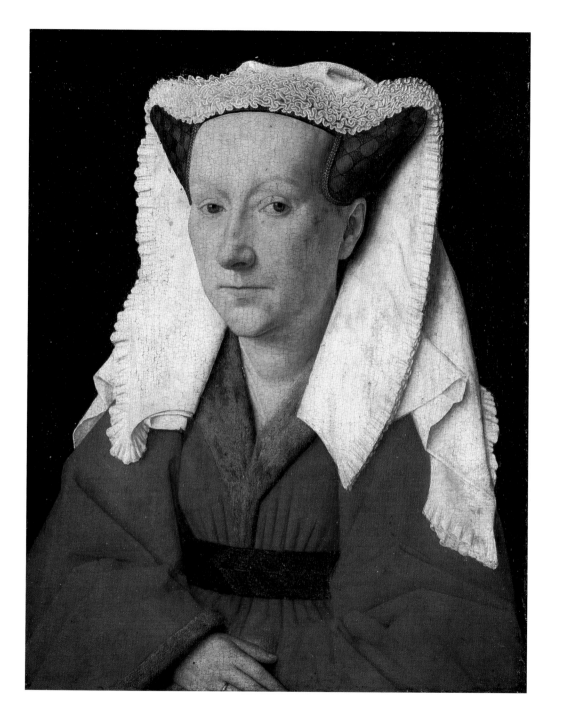

St Jerome in his Study

c. 1440–1442

Oil on paper on panel, 19.9 x 12.5 cm
The Detroit Institute of Arts, Detroit

It has proved difficult to establish the truth about the authorship of this panel. Only discovered last century, it was at first attributed to Petrus Christus working from a prototype by van Eyck's. Other scholars have attributed it to the master himself, dating it to before the execution of the *Ghent Altarpiece.*

When subsequently the date 1442 was discovered painted on one of the walls, the previous hypotheses had to be rethought. Panofsky suggested that van Eyck had started the work, which was finished posthumously by his workshop. Opinion remains divided as to van Eyck's degree of involvement with the painting, but the authorship of Petrus Christus has now been ruled out. St Jerome is depicted as a scholar seated at his desk in a study crammed with intriguing objects. Alongside numerous scholarly tomes, there is a folded letter and an hourglass. As in many other paintings of him, the saint is shown wearing the robes of a cardinal, though in reality he never held that office. His attribute is the lion, which is said to have become his tame companion after the saint removed a thorn from its paw. St Jerome was a translator of the Bible, and his translation, known as the Vulgate, was accepted as the official Latin version by the Council of Trent (1545–1563). As an intellectual, St Jerome was regarded as an early humanist, and was therefore often represented in Renaissance art. Similar scenes became common throughout Europe, two well-known examples being the paintings by Antonello da Messina and Albrecht Dürer.

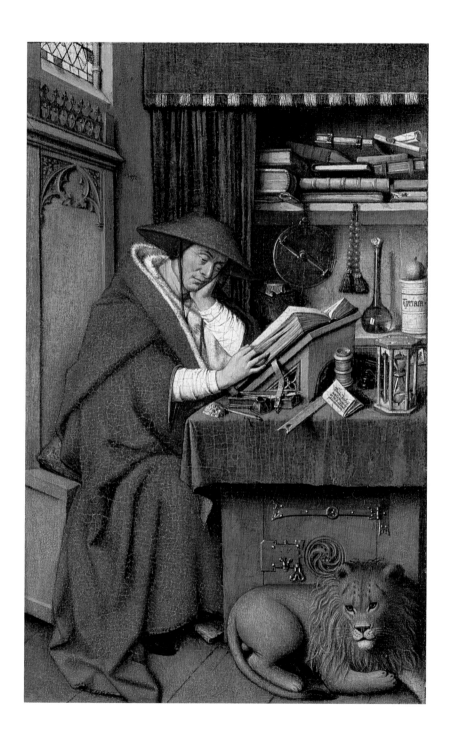

St Jerome in his Study (details)

The Crucifixion

c. 1440–1450

Workshop of van Eyck
Oil on panel, 46 x 31 cm
Galleria Franchetti at the Ca' d'Oro, Venice

This painting has a complex historiography. Known not to be by the hand of the master himself, it has in turn been attributed to van Eyck's older brother, Hubert, to his workshop, or to an assistant or follower. It has even been interpreted as a copy of a lost original. Whatever its origins, the work exerted a considerable influence over Italian painting. Dating from some time prior to the mid-fifteenth century, it found its way to the Veneto soon afterwards, and was considered to be a copy of a lost proto-type by van Eyck, which may have existed in Venice. The same prototype seems to have influenced *The Crucifixion* miniature contained in the *Turin-Milan Hours,* along with other panels in Padua and the Galleria dell'Accademia in Venice. This sequence of similar paintings testifies to the eagerness of Italian artists to emulate the Flemish master and his iconography. The tiny Calvary scene takes place in front of an imposing cityscape of such precision and accuracy that it can clearly be identified as Jerusalem. In the foreground, the solemn figures of Mary and John manage to retain their composure, unlike the cluster of weeping women on the left. On the right, the horsemen preparing to depart are as non-chalant as if this were an everyday occurrence.

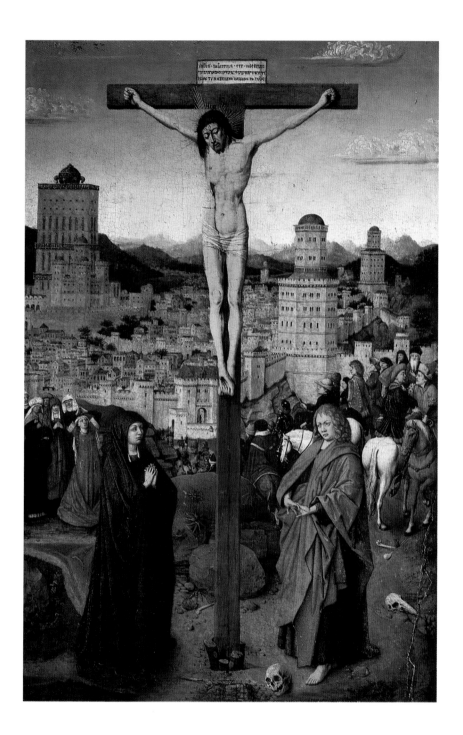

The Fountain of Life

c. 1445–1450

Workshop of van Eyck
Oil on panel, 181 x 119 cm
Museo Nacional del Prado, Madrid

The origins of this panel remain a mystery. It has variously been held to be a copy of a lost original by van Eyck, attributed to an assistant, or to his older brother Hubert, given the similarity between its motifs and those of the *Ghent Altarpiece*, which the brothers worked on together. It seems unlikely to be the latter, as it would then date from an earlier period than seems feasible. Some have suggested the authorship of Petrus Christus. What is known for definite is that it was commissioned by Henry IV of Castile, and given to the convent of Nostra Signora del Parrai in Segovia. This work, along with a triptych by Rogier van der Weyden, also in Castile, became extremely well known there. The Flemish influence of van Eyck, van der Weyden and their followers was a determining factor in the development of local art during the course of the fifteenth century, and *The Fountain of Life* was replicated many times over. The composition is arranged over a grandiose, illusionistic architectural scheme that comprises three levels. On the upper level, God the Father is seated under a monumental Gothic baldachin, flanked by the Virgin and St John the Baptist. The configuration resembles that of the *Deësis* in the *Ghent Altarpiece*. Beneath the central figure is the Apocryphal Lamb, and the central throne is adorned with the symbols of the Evangelists. The baldachin is decorated with statues of the Old Testament Prophets. Underneath, angel musicians are playing their instruments on the grass, whilst choirs of angels are singing on either side in the towers. In the foreground on the lower level, the fountain of life divides the serene Christians on the left from the despairing Jews on the right, in a scene that represents the triumph of the Church over the Synagogue. The fountain of life was a popular icon in Flemish devotional iconography.

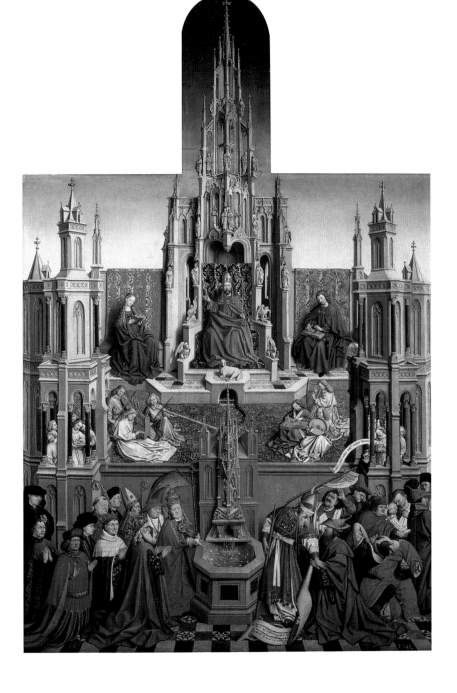

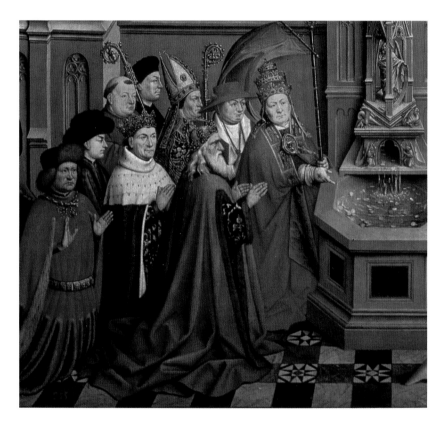

*The Fountain of Life
(details)*

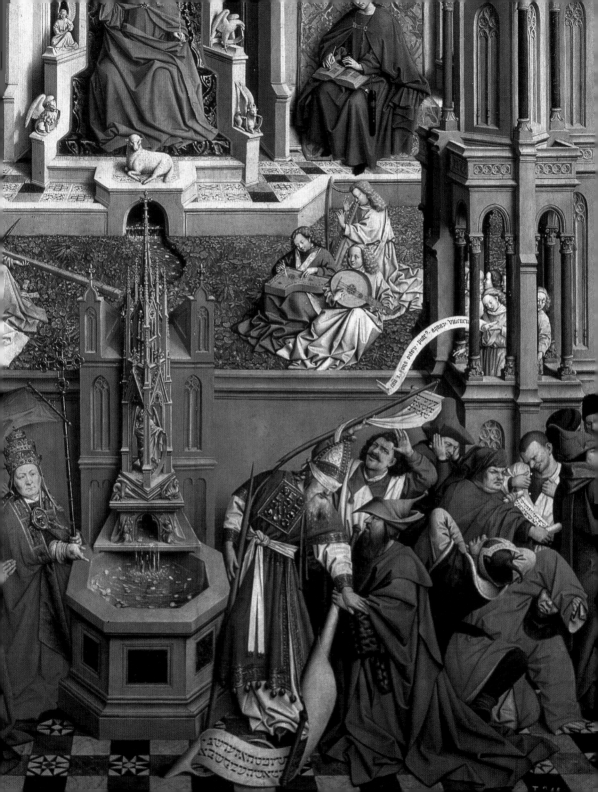

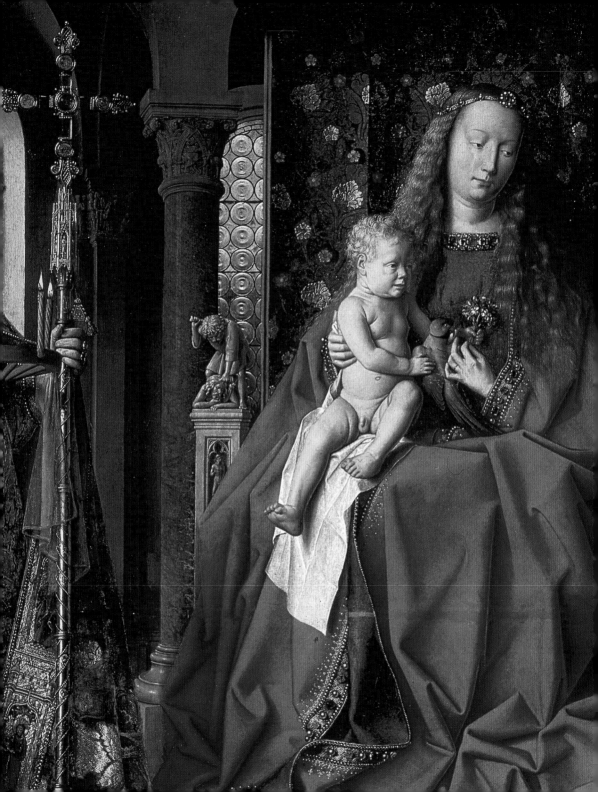

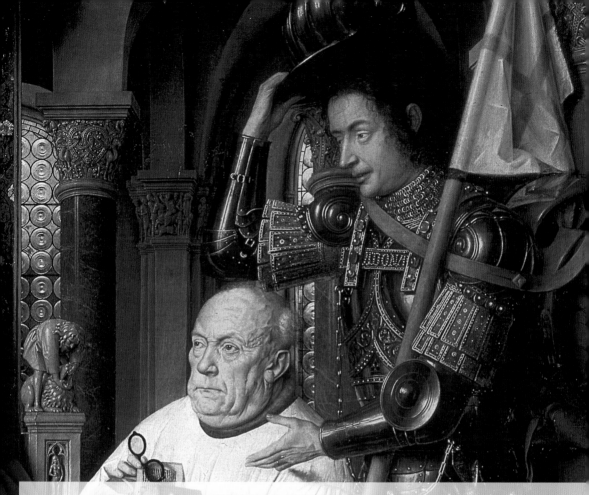

THE ARTIST AND THE MAN

Van Eyck in Close-Up

An extraordinary technique

One of the most significant factors in the development of Western art was the invention of oil painting. It was the painter and historiographer Vasari who attributed this invention to Jan van Eyck: "It was first invented in Flanders by Johann of Bruges [...] who succeeded in coloring using oil." Although Vasari's *Lives of the Artists* (1550 and 1568) remains an indispensable source of information, some of his facts are less than reliable. He also makes the unsubstantiated claim that Antonello da Messina had traveled to Flanders with the specific aim of learning the technique, and that van Eyck, who guarded his secret closely, did in fact teach him the new technique, which he then brought back to Italy. The truth of the matter is that the technique of oil-painting already existed in medieval times, as documented in a treatise written by the monk Theophilus in the twelfth century, and by the Italian artist Cennino Cennini, active in the late fourteenth and early fifteenth centuries. The fifteenth-century Italian humanist Bartolomeo Facio also wrote of van Eyck's use of the technique, but linked it with other authors such as Pliny. So whilst the use of oil paint clearly did not begin with van Eyck, he was the first artist to employ the technique systematically from the early fifteenth century, with the result that it became widely diffused across Europe, and Italy in particular—one has only to think of artists such as Piero della Francesca and Giovanni Bellini. The procedure involved mixing the pigment with a new type of binding agent—linseed oil, walnut oil, or poppy-seed oil—as well as the traditional ingredients used to mix paint and tempera: milk, egg-white, casein, and gum. The results were extraordinary, and enabled the creation of a whole new spectrum of pictorial effects, with far more variation than had been possible previously. With this new medium, van Eyck was able to discover new methods of painting that opened up new horizons artistically. Colors could now be layered on top of each other thinly, enhancing the chromatic effects; the rendition of light became more shimmering and subtle. The technique also facilitated a new form of realism—it was not the realism of the Italian painters, where the universe was governed by rules of symmetry and proportion, but an analytical realism capable of depicting the tiniest detail and nuance of light, color, atmosphere, and expression. The development of oil painting also influenced the emergence of other genres, such as portraiture and the painting of landscapes. Van Eyck was able to diversify his approach to portraiture, introducing half-length, full-length, and even life-size figures, an approach that was particularly influential in Italy. His ability to paint in such detail allowed him a whole new gamut of expressions with which to portray different characters. His depiction of the natural world was unprecedented. At a time when landscape painting was unheard of as a genre in its own right, van Eyck's glimpses of landscape were an integral part of his painting, not a peripheral one, as was the tradition. In contemporary Renaissance art, landscapes were marginalized; they were subordinate to the more important considerations of human figure, design, anatomy, and perspective. It was quite the opposite with van Eyck, where the landscape played a fundamental role in the composition, both from a natural, and often from a symbolic, point of view. His famous paintings *St Francis Receiving the Stigmata* would have little impact without the powerful surrounding landscapes. Here, remarkably, the religious

theme seems here to be merely a pretext for an extraordinarily naturalistic reconstruction of the countryside. Even in other works where the space is more restricted, it is the glimpses of the natural world that are most arresting and most memorable. For example, the detailed background landscape of the *Rolin Madonna* was highly influential in the development of Italian art. Surely van Eyck's ultimate triumph of landscape must be the in the *Ghent Altarpiece*: the closed wings show the scene of *The Annunciation* with its evocative cityscape, and when the wings are opened they reveal the magnificence of paradise in *The Adoration of the Mystic Lamb*.

The tragic genius: the debunking of a myth

It has long been the fate of an artist to be the subject of myths and stereotypes, the most common one being that of the tragic genius, impoverished and misunderstood, a slave to his own passions. It is true that many artists have not been recognized within their lifetimes, and that the nature of genius is not always easily comprehensible. Some artists do confirm to the stereotype—one has only to think of the dramatic events in the life of Caravaggio for example, or the fact that Leonardo da Vinci failed to achieve the social or financial recognition he deserved, many of his patrons being less than discerning about his art.

Van Eyck did not suffer this traditional fate in the slightest. There may have been the occasional times in the centuries following his death when his art was less well appreciated or understood, but during his own lifetime he was highly regarded, his fame such that he was erroneously credited with the invention of oil painting. His career got off to a most auspicious start when he was appointed court painter to Philip the Good, Duke of Burgundy, with immediate access to the entire court entourage. In the fifteenth century a successful artist needed patronage and opportunity, and it was imperative that he could conduct himself in a fitting manner to move in the necessary circles. In Italy, Andrea Mantegna won international renown as court painter for three successive generations of the Gonzaga family in Mantua. Similarly, van Eyck worked for the most important ruler in Northern Europe, and he became not only an artistic point of reference for his generation, but also the faithful confidant of the Duke, who entrusted him with several important and secret diplomatic missions.

Another widespread myth surrounding the artist concerns the nature of his personality, a topic that has been explored in Rudolf Wittkower's book *Born under Saturn: The Character and Conduct of Artists* (1963). The artistic personality is deemed to be capricious, eccentric, intemperate, dark, and brooding. Of course there have been examples of such behavior, but they are the exception rather than the rule. More often it has been the case that the artist has had to suffer the whims of the patron or employer. The most desirable situation has always been when the artistic temperament manages to co-exist happily with the customs and demands of the social circle providing the employment prospects for the artist, and this was exactly what happened in van Eyck's case. Raphael played the role of the courtier with consummate ease, and became a favorite with the papacy and the aristocracy. It is very likely that van Eyck would not have enjoyed the success he did had he not been so able to comport himself in the right manner. In the fifteenth century, even a relatively affluent artist like van Eyck was still dependent on receiving regular commissions, and he need-

ed to be able to converse with people of much higher social standing. Van Eyck's extensive and varied list of patrons, and his constant employment, testify to the fact that his was not at all a tragic genius.

A testament of success: peons of praise

Van Eyck's success as an artist is attested by the wealth of adulatory descriptions of his work written during the Renaissance. He was highly regarded by the humanists of the Italian courts, most notably by Bartolomeo Facio, pupil of Guarino da Verona, and secretary to King Alfonso V of Naples. In his book *De viris illustribis* (1456), in which he describes the lives of over ninety illustrious contemporaries, Facio includes the biographies of four painters: Gentile da Fabriano, van Eyck, Pisanello, and Rogier van der Weyden. It is significant that the list included two Flemish painters, which seems to contradict the idea of Italian supremacy in the art of the Renaissance, and indicates how widespread the fame of the Flemish school had become. He judges van Eyck to be "the greatest painter of our time," an opinion which was clearly shared by many of his contemporaries. He acknowledges him to be an expert in geometry and in all pictorial arts, refers to his practical skills, and describes how van Eyck read the works of Pliny and discovered new methods of using color. He continues in praise of the beauty of his paintings, their verisimilitude and vibrancy, and mentions van Eyck's use of the mirror as a device to create a sense of depth and three-dimensionality.

Another Italian man of letters, Ciriaco d'Ancona, describes him as a "most noble illusionist" (1449), capable of producing art that seems to be of divine provenance rather than human. Giovanni Santi, who is better known for being the father of Raphael than for his own artistic merits, described how van Eyck was more highly praised than any other artist in Bruges, and how his skillful use of color created a world more beautiful than that of real life, a concept that was popular during the Renaissance.

Despite his prejudice in favor of Tuscan artists and his limited comprehension of artistic values not founded on geometry and perspective, Vasari was fulsome in his praise of van Eyck, although wrongly attributing the invention of oil painting to him. The French poet Jean Lemaire de Belges spent time at the court of Margaret of Austria, governor of the Low Countries, who was in possession of some of van Eyck's works. In his poem based on life at the court, *La Couronne Margaretique* (1549), he extols the paintings for their wealth of detail, and proclaims that immortality will be the artist's destiny. Perhaps the most rhapsodic praise came from the German artist who followed in his footsteps and achieved international fame himself, Albrecht Dürer. Dürer visited the Low Countries in 1520 and saw first-hand such works as the *Ghent Altarpiece*, and the paintings belonging to Margaret of Austria, including *The Arnolfini Marriage,* and wrote ecstatically of his reactions to the work of his Flemish predecessor.

Italian commissions

Many of van Eyck's paintings on a variety of different subjects were commissioned by Italians and ended up in Italy. This testifies to the popularity of the Flemish style in the fifteenth century, a popularity that extended beyond the local and national sphere to become truly international. One of the European rulers who most admired van Eyck's work

was Alfonso of Aragon, King of Naples. His collection included the *Trittico Lomellini* (now lost), which was originally commissioned by the Genoese merchant Battista Lomellini, *St Jerome in his Study*, an *Annunciation*, and a *St John the Baptist.* Van Eyck's *St Jerome in his Study* seems highly likely to have influenced the painting of the same title by the Sicilian painter Antonello da Messina (now in London), who would have had the opportunity to see the work in Italy. The King of Naples also possessed a painting of *St George*. The two versions of *St Francis Receiving the Stigmata* also had an Italian connection, for they were owned by the Adornes family who came from Genoa but lived and worked in Bruges, and were then transferred to Venice. There they would have been certain to influence the Venetian school of painting, which included Giovanni Bellini and Antonello da Messina. There are many similarities between the Venetian painters and van Eyck in terms of luminosity, color, and tonality. A further significant painting that found its way to Italy was his *Woman at her Toilette*, which was sadly lost. This painting was originally housed in the collection belonging to Ottaviano della Carda, nephew of Federico da Montefeltro, Duke of Urbino. It ended up in the seventeenth century in the Antwerp art collection of Cornelius van der Gheest, where it was depicted in 1628 by Willem van Haecht. An early copy is now in the Fogg Art Museum, Cambridge, MA. The painting is a rare example of a secular theme within van Eyck's oeuvre, and bears the hallmarks of his luminous style.

Isabella d'Este was an important patron of the arts at her court in Mantua, and created a famous *studiolo* in the castle, which was richly decorated with paintings. She commissioned works by Mantegna, Bellini and Leonardo. The powerful Italian patrons competed with each other to obtain prestigious paintings, and when Isabella heard that the Venetian Michele Vianello was in possession of van Eyck's *Drowning of Pharaoh in the Red Sea*, a popular theme in the art of Northern Europe, she made strenuous efforts to obtain it, but all to no avail.

The wealthy textile merchant from Lucca, Giovanni Arnolfini, had his portrait painted twice by van Eyck; once alongside his wife in the famous *Arnolfini Marriage*, and once in an individual portrait, now in Berlin. In a further connection with Genoa, the *Dresden Triptych* (1437) bears the coat of arms of the Giustiniani family, who had established themselves as successful merchants in Bruges. It is possible that it was commissioned by Michele Giustiniani, given the presence of his patron saint in the panel. Before the end of the century, the painting had been transferred to Genoa, where it influenced local artists. Finally, there is mention of a work by van Eyck in the cradle of the Renaissance itself, the city of Florence, where the appearance of the *Portinari Triptych* by Hugo van der Goes had caused a stir in artistic circles. An inventory drawn up after the death of Lorenzo the Magnificent in 1492 mentions a small painting of St Jerome enclosed in a case. Two conclusions can be drawn from the extent of the Italian commissions that were forthcoming for van Eyck. Firstly, it shows that the Italians themselves were far from parochial in their attitude to art and culture, and actively welcomed foreign influences. Secondly, it proves that van Eyck's vision was as powerful as that of the Italian Renaissance, with its emphasis on mathematics, geometry and perspective. His vision of the real world, portrayed in all its detail, held an enduring fascination for the most sophisticated of tastes.

The power of mimesis

The two most important concepts that shaped the Renaissance were the rediscovery of classical antiquity, and the idea of art as mimesis—art as a truthful representation of the real world. The latter concept was not new to Western culture, but during the Renaissance it was reexamined and given a greater significance. Aristotle was one of the first to discuss the possibilities of verisimilitude in art, arguing that it was preferable to sterile prototypes. Ancient Roman authors echoed his thoughts, praising artists who were able to create the illusion of reality in their paintings. During the Middle Ages the concept of mimesis sank almost into oblivion, and was replaced by a Christian vision that emphasized the transcendental and the metaphysical, severing the connection between the artist and the real world. The focus shifted from the exterior world to the interior spiritual realm, and medieval art became formulaic and symbolic. The Renaissance sought to overturn these anachronistic images, and returned to the theme of mimesis with enthusiasm and fresh ideas. The aim of achieving the perfect illusion of reality once again became the aim of the artist, and the idea was a topic of debate not only in Italy but across Europe, albeit with different emphases. Naturally it spread as far as Flanders, where van Eyck's paintings contributed to the general dialogue, and helped to establish him as an international figure. One of the most controversial arguments in Italy concerned which could be considered the supreme art, painting or sculpture. Through his creations, van Eyck argued in favor of painting, with its limitless ability to portray every aspect of the real world. Vasari compiled a list of those aspects which were beyond the capabilities of the sculptor: rivers, wind, storms, lightning, rain, thunderclouds, hail, sunlight, brilliance, moonlight, obscurity, fire, smoke, and sparks. He also argued that painting was better able to render the surface appearance of objects, such as the texture of brocade, the smoothness of silk, and the warmth of fur. It was also able to create flashes of brilliance glinting on a crown or a jewel, and subtle gradations of tone. This affirmation of the art of painting paved the way for a new genre, that of landscape painting, which developed first across Northern Europe. Its exponents included van Eyck, Rogier van der Weyden, Hieronymus Bosch and Joachim Patinier, and its influence was felt in some sectors of Italian painting. In general, representations of landscapes in Italian art were abstract and stylized, lacking in creativity. With van Eyck came an innovative approach: he looked at nature with the eye of a botanist or scientist; trees, meadows, flowers, lakes and mountains were all scrutinized and reproduced faithfully, down to the very last detail. One cannot help but make a comparison here with Leonardo da Vinci in his scientific and analytical approach to painting, and in his desire to represent the real world. Many scholars have identified elements of the Flemish style in the works of Leonardo.

Van Eyck's modus operandi was liberal and comprehensive; he wanted his art to be as inclusive as possible. He was free from the constraints imposed on his fellow artists in Italy, where anything that did not concern perspective, spatial relations, or clear narrative was relegated to second place. There was a particular disregard for landscapes and still art. Valid though the vi-

sion of the Italians was given the recent discoveries, it was van Eyck's personal vision that allowed him to create the perfect mimesis that resonates throughout his works.

The mirror as an artistic device

One of the most distinctive motifs of Flemish art is the depiction of a mirror within a painting. Examples of the use of this device can be found in the works of van Eyck, Robert Campin, and Hans Memling. Its most obvious purpose was as an object to reflect light, and so to create flashes of brilliance within the painting. Van Eyck also used it to even greater effect as a means of expanding the pictorial space beyond the confines of the painting. This is exemplified in the famous double portrait of *The Arnolfini Marriage,* where the mirror on the far wall serves not only to increase the play of light in the painting, but also to reflect the world occupied by artist and his companion, and by the viewer. In this respect the viewer becomes a participant, a witness to the momentous events taking place in front of him.

Further examples of the use of a mirror as an artistic device can be found amongst the works of Italian painters such as Giovanni Bellini, Titian, Giorgione, and Girolamo Savoldo. Earlier on, the Florentine architect Brunelleschi had made use of a mirror in his experiments with perspective: he drilled a central hole through a panel on which he had painted a depiction of the Baptistery in Florence, with the intention that the viewer should hold the unpainted side against one eye, holding a mirror in the other hand in which to view the reflection of the panel. The aim was to test the authenticity of his application of perspective by using the laws of geometrical optics. In

the second book of his treatise *De Pictura,* Alberti recommends the use of a mirror as an instrument to highlight the weaknesses of a pictorial composition and thus enable their correction—he deems the mirror a better judge than the human eye. He even goes so far as to say that the mirror can correct the appearance of things taken from nature. There is an implicit assumption that nature itself can be improved upon in the pursuit of an even greater beauty. This assumption is understandable in the writings of an Italian humanist preoccupied with the concepts of proportion and symmetry, but such a concept was far from the philosophy of van Eyck. In his *Treatise on Painting,* Leonardo da Vinci makes several references to the use of mirrors, also recommending their usefulness in the correction of mistakes, as Alberti does. Leonardo does not imply that nature can be improved upon, for to him this would have been unthinkable. He goes on to discuss aspects such as chiaroscuro, foreshortening, light and shade, and surfaces. Unlike his fellow Florentine artists, he does not subscribe to the use of a mirror in order to achieve volumetric plasticity, but to achieve subtle nuances of light, shape and atmosphere. He concludes by saying that there was a definite limit beyond which an artist could never go in terms of verisimilitude: "Painters frequently sink into the depths of despair because their paintings do not appear as realistic as what they can see in reflected in a mirror. Painting can never render things identical with nature."

The mirror is therefore an instrument of mimesis, of the desirable but impossible identification between painting and reality, art and nature. Various fifteenth century sources also speak of its role in the debate as to the su-

premacy of painting vis-à-vis sculpture, alluding to a lost painting of St George by Giorgione in which there are not one but two mirrors, reflecting the subject of the painting from several angles. It was then argued that painting was therefore the superior art, given that by using this device the entire subject could be seen from a single vantage point, which of course is impossible with a work of sculpture.

In his use of the mirror as an artistic device, van Eyck showed himself to be once again at the vanguard of his art, employing a motif that was to remain of great interest to the artists and theorists who succeeded him.

The aesthetics of light

Whilst the Italian Renaissance sought inspiration in the models of classical antiquity, van Eyck was proposing new typologies, as for example in portraiture, and also making use of stylistic devices both old and new. For the great Italian masters, such as Piero della Francesca, Michelangelo, and Raphael, design was of paramount importance. Van Eyck wanted to move away from the abstract and idealized reconstruction of the world, with its exegetical format, and introduced a new paradigm into his paintings: the aesthetics of light. It was undoubtedly his use of oil painting that enabled him to explore this area more fully. He was not alone in assigning such importance to the role of light in the true representation of reality; his opinions were clearly shared by fellow artists such as Masaccio, Piero della Francesca, and Caravaggio, but the similarities between them are more superficial than real. One of the earliest hallmarks of Italian Renaissance painting was the insistence on the use of chiaroscuro in modeling the figures and giving them a sense of space. In

the paintings of Piero della Francesca, light is not employed in a realistic manner, but in a way that creates an abstract, metaphysical impression. It is a geometric calculation of effect within a mathematical vision of reality. Caravaggio's rays of light cut across the canvas, creating a structure and defining the images. These examples suffice to show that in Italian art the guiding principle was that of *lumen*, a uniform light source able to calibrate space and characterize form: figures appear like sculptures, the structure is clear, and the representation plausible. An artificial reality is created by means of a formula. In the gilded world of Flemish art and van Eyck in particular, the guiding principle was instead that of *lustro* (luster), a mobile, fluctuating light intended not for the modeling of form in robust chiaroscuro, but for creating nuances of atmosphere and subtleties of form. The norms of Italian art give way to a shimmering realm in which the surface of every object is treated differently. Light and texture are now the key elements.

Free from the constraints of using light within the context of perspective, van Eyck proceeds to use it in different ways. In the *Madonna in a Church* he uses it to emphasize the grandiose structure of the building, and to accentuate the richness and beauty of the Virgin and her symbolic spiritual significance. In his portraits of illustrious people, he uses touches of light to highlight their rich apparel and the symbols of their power. In other paintings he uses light to establish a sense of spatial depth behind his figures, and he uses this to particular effect in his trompe-l'oeil sculptures. Van Eyck was the first painter to use light with such skill and versatility, the like of which has scarcely been surpassed. The dis-

tinction between the two types of light had been made as early as Pliny, who identified them in his writings as *lumen* and *splendor*. Leonardo also made reference to them in his *Treatise on Painting*, which was unusual given his Tuscan origins and Florentine education. In many respects he was atypical of his fellow artists: whilst giving equal weight to the importance of design, he also attached importance to those elements favored by van Eyck, both in terms of landscape and in terms of the luminosity for which he is famous.

Approaches to the problem of illusionism

When drawing a comparison between contemporary Italian and Flemish artists, between Masaccio and van Eyck for example, a common generalization often made is that the former have a scientific approach whilst the latter have an empirical approach; the former are concerned with the use of perspective and the needs of the narrative, whilst the latter observe the cosmos and reproduce it painstakingly in all its detail. That assumption is basically correct, but only with one or two important provisos. Firstly, empiricism should never be considered inferior to science, and secondly, the "autumn of the medieval" (Huizinga) should not be considered inferior to humanism. The "autumn of the medieval" has sometimes mistakenly been taken for an anachronistic, unsophisticated period, whereas in fact quite the opposite is true. The Flemish artists, especially van Eyck, were intent on finding solutions to the same problems as the Italian artists. All of them were exploring the issue of illusionism within painting, and the Flemish artists found their own solutions, even though these were quite different to the mathematical, abstract methods of Piero della Francesca and other Italian artists.

One of the fundamental issues facing the all the painters was how to overcome the physical confines of the picture, given the new imperative to create the illusion of space within it. Van Eyck explores this in his *Madonna in a Church*, where in addition to the central space he depicts another chapel visible beyond the arch, thus creating a sense of depth and adding a second pictorial plane. This was a device typical of many Northern painters, including Jan Vermeer. Other architectural devices used to create additional space and depth were cornices, niches, parapets, and windows. Windows were the most illusionistic tool of all, for they draw the eye of the spectator, act as a partition between the interior and the exterior, and allow a glimpse into a world beyond, usually featuring a landscape. In time, landscape painting became an established genre in is own right. Van Eyck first explores the use of windows in the *Ghent Altarpiece* of 1432, where *The Annunciation* on the closed wings shows a series of arches with a cityscape visible beyond. He also includes several different niches ostensibly to display symbolic objects, but also adding to the illusion of depth. Another striking example of illusionism is found in the *Rolin Madonna*, which contains three pictorial planes. In the foreground are the central figures; through the tripartite arcade behind them there is a garden, which forms the second plane; in the garden, tiny figures are looking out across a wonderful landscape, which forms the third plane. The attention of the viewer is engaged in each of these different levels, not just in the encounter between the donor and the Virgin.

Naturally, the Flemish were not alone in using illusionistic devices such as parapets and windows. In Italy, Alberti likened a painting to an open window through which the viewer can perceive a scene in perspective, thanks to the application of mathematical principles. Either side of the Alps, artists were addressing the same problems and finding different solutions.

The evolution of landscape painting owes much to van Eyck, who established it by degrees in his own works. Initially it appears as a glimpse, almost as an accessory, or as an impressive background to a momentous scene such as *The Adoration of the Lamb* in the *Ghent Altarpiece*. By the time he painted the two versions of *St Francis Receiving the Stigmata*, the landscape has become more important that the central theme, which is in itself a radical development, and an important step in the development of the genre.

Innovations in portraiture

The portraits of van Eyck are universally acknowledged to be amongst the most important and innovative works of his oeuvre. He was responsible for introducing new typologies, such as that of the double portrait. His characteristic touches included the use of frames and parapets as illusionistic devices, and the use of inscriptions and signatures. Van Eyck's approach to painting in general was exploratory; he was continually seeking new methods of composition. In contrast, his most famous successor, Rogier van der Weyden, was an inventor of new iconographies and motifs that had a greater emotional impact, such as the swirls of cloth around Christ's loins in the Crucifixion, and the stiff wooden body set on the diagonal in the Deposition.

Panofsky has written extensively on the mimetic qualities of van Eyck's portraits, and his portrayal of a world seen as if through a mirror, magnifying glass, telescope or microscope, in the distance or close-up. This quasi-scientific approach allowed him to explore his themes in greater depth, and with a greater degree of reality. Despite this, Panofsky has identified a perceptible lack of emotion in his portraits; his subjects appear somewhat detached. The portraits therefore have a descriptive function, rather than an interpretative one, and it is difficult to establish the nature of their thoughts and their emotional state. This is a far cry from the style of Leonardo, who was anxious to depict what he termed the "movements of the spirit." However, as Panofsky points out, it is precisely this lack of a specific psychological dimension that increases the allure and ambiguity of the portraits. Their aloofness both repels and attracts the viewer, who becomes curious about the mysterious person portrayed. To a large extent, the portraits remain enigmatic, and this is exacerbated by van Eyck's innovative use of the mirror. He was the first artist to use the mirror in a painting as a means of reflecting his own image as an indirect self-portrait. Perhaps this should not seem surprising, considering that he was the first Flemish artist to sign his own paintings. The most famous example of this is in *The Arnolfini Marriage*, where amongst a abundance of images representing marital fidelity, it is the mirror on the far wall which attracts our attention. The reflection in the mirror clearly shows the presence of the artist and a companion, and these figures have been interpreted as being witnesses to the solemnization of matrimony. Their presence

also shows the desire of the artist to include himself in his picture, and this idea was to become extremely popular amongst artists, who would depict themselves hard at work at their easels.

An interesting variation on this theme is found in the *Madonna of Joris van der Paele*. In this painting there is no mirror, but van Eyck uses the reflections seen on St George's coat of armor to the same effect. Tiny fragments of the scene are visible on the shining surface, and there is an additional reflection of a man with a brush in his hand, who has been identified as the painter, scrutinizing the perspective of his work. This minute self-portrait on the far right of the painting is a long way from the boldness of Dürer's later self-portrait as Christ, housed in Munich. However, it is a subtle and sophisticated allusion that reveals the artist's desire to be identified within the work.

The power of symbolism

Many Renaissance paintings are full of symbolic allusions, some of which are easy to decipher, others not. Van Eyck is no exception, despite his reputation for realism. This syncretism is typical of the Renaissance, which embraced the microcosm and the macrocosm, the human and the divine, civic pride and religious fervor, superficial realism and profound symbolism (which harked back to the medieval world of not long before). They were all different facets of the same movement. The iconic portrait *The Arnolfini Marriage* is a case in point, being readable on many different levels. It addresses problems of perspective, the role of the artist, the depiction of an interior, but in addition it is laden with symbolism. There are two specific gestures that represent the rite of matrimony: the joining of hands (*fides manualis*), and the raised right forearm of the man (*fides levata*). It should not come as a surprise that the couple are alone, for at that time the Catholic Church did not require the presence of an official at a marriage ceremony, only witnesses. It was not until the Council of Trent (1545–1563) that the law changed to demand the offices of a cleric. By painting the inscription "Van Eyck was present," he is documenting his role as witness to the sacrament. The choice of a bedchamber as the setting of the portrait rather than a living room is significant, as is the presence of a tiny statue of St Margaret, patron saint of childbirth, by the bed. The fruit on the windowsill and table (also present in the *Lucca Madonna* and the *Ince Hall Madonna*) refer to the loss of innocence in the Garden of Eden and the Fall.

Further examples of symbolism can be found in the *Lucca Madonna*: the apple held by the Infant Christ is a recurrent motif referring to his future Passion. Other references include a book of Holy Scripture held by the Virgin or the Child, and the touching of the Child's foot by his mother, an allusion to the future wounds it would bear. Although the role of symbolism was most in evidence in religious paintings, its use was not confined to this sphere. Many profane symbols were used to identify the role or occupation of important personages, as in the portrait of Baudouin de Lannoy.

Anthology

Johannes Gallicus is considered first amongst the painters of our century, thoroughly versed in the sciences, geometry in particular, and in those arts that may serve as a supplement to painting. He is credited with the discovery of new properties concerning color, having studied the writings of Pliny and other ancient authors on the subject. One of his most notable works, which is housed in the private apartments of King Alfonso, shows an astonishingly beautiful and modest Virgin, and a radiant angel with hair so natural that it seems almost tangible, who announces the birth of the son of God. Alongside this painting hang a St John the Baptist, whose holiness and austerity are palpable, and a wonderfully realistic St Jerome pictured in his study.

Other works of great renown are in the possession of the illustrious Ottaviano della Carda. They include women of extraordinary beauty coming out of the bath, the most intimate parts of their bodies delicately covered with thin cloths. In one of the figures, only the face and upper body are visible, but the entire body is shown in rear-view by means of a mirror, so that both sides can indeed be seen at once. This panel also shows an incredibly lifelike oil-lamp, a puppy lapping up water, minute horses and men, along with mountains, woods, villages and castles: seem-ingly thousands of different figures all painted with consummate skill. But the most beautiful thing of all in this picture is the mirror in which the entire work is reflected, just as if in a real mirror. He is said to have painted many other works, but I have been unable to verify this.

Bartolomeo Facio
De viris illustribus, 1456

When I reached Ghent, I saw Johannes' panel, the *Adoration of the Lamb*; a splendid work, and intelligently painted. The figures of Eve, Mary and God the Father are particularly fine.

Albrecht Dürer
Journey to the Low Countries, 1521

That marvelous and useful invention in painting, that of painting in oils, was first invented in Flanders by Johann of Bruges [Jan van Eyck]. He sent his work to Naples, to King Alfonso, and to the Duke of Urbino, Federico II. He also made a *St Jerome* owned by Lorenzo de' Medici, along with many other paintings of renown. [...]

It came to pass that while working in Flanders, Johann of Bruges, a painter much esteemed in those parts by rea-

son of the great mastery that he had acquired in his profession [...] began to look for a method of making a varnish that should dry in the shade, without putting his pictures in the sun. Wherefore, after he had made many experiments with substances both pure and mixed together, he found at length that linseed oil and walnut oil dried more readily than all the others that he had tried. These then, boiled together with other mixtures of his, gave him that varnish that he had long desired [...]

Rejoicing greatly over such a discovery, as was only reasonable, Johann made a beginning with many works, and, assisted by experience from day to day, he kept on ever making greater and better works. The fame of this invention spread not only through Flanders, but to Italy and many other parts of the world, and great desire was aroused in other artists to know how he brought his works to such perfection. And seeing his pictures, and not knowing how they were done, they were obliged to give him great praise.

Giorgio Vasari
Lives of the Artists, 1550

For what was never granted to either the ingenious Greeks, Romans or other peoples to discover—however hard they tried—was brought to light by the famous Netherlander, Jan van Eyck. Art-loving Italy could only behold his work with complete astonishment, and had to send her artists there so as to suckle at new breasts in Flanders. From an early age Jan van Eyck was highly intelligent and of very quick and noble mind, and being naturally inclined to the art of drawing he became a pupil of his brother Hubert, who was a good few years older than he [...] And because the town of Bruges in Flanders overflowed with much wealth in former times, on account of the great commerce which was carried on there by various nations, Jan went to live in the afore-mentioned town of Bruges where all manner of merchants abounded. Here he made many works on wood with glue and egg—and was very famous because of his great art in the various countries to which his works were taken. He was (according to some) also a wise, learned man, very inventive and ingenious in various aspects of art; he investigated numerous kinds of paint and to that end practiced alchemy and distillation. He got so far as to succeed in varnishing his egg or glue paint with a varnish made of various oils which pleased the public

very much as it gave the work a clear, brilliant shine. In Italy many had searched for this secret in vain, for they could not find the correct technique [...]

Our art need only this noble invention to approximate to, or be more like, nature in her forms. Had the ancient Greeks—Apelles, Zeuxis and others—been brought back to life again here and seen this new technique, they would certainly have been astonished.

Karl van Mander
Lives of the Illustrious Netherlandish and German Painters, 1604

Where had the van Eyck brothers come from when they arrived in Ghent and joined the existing community of artists? What had led them there? What did they find when they got there? What was the true significance of their discoveries in the use of oil-painting? What role did each one of them play in the creation of the *Ghent Altarpiece*? All these questions have been discussed at length by scholars, but they remain as yet largely unanswered. [...]

Superficially at least, some parallels can be drawn between van Eyck and Memling: both artists inhabit the same world of opulence and affluence, and their paintings are resplendent with touches of luxury: rich fabrics, gold, pearls,

silks, velvets, marble, engraved metals. The art of painting was an art to rival that of the goldsmiths, engravers and enamellists. There is a virility about van Eyck's portraits: the composition is strong, and the subjects themselves seem warm-blooded and muscular. They are similar to the portraits of Holbein in their precision, and are at times equally penetrating and unforgiving. His palette of colors is richer and more robust than that of Memling, and his use of them is more varied and refined [...] Van Eyck is more skillful than Memling because he seems more certain of his purpose, more confident, more determined. He is a master of imitation: when painting a carpet he chooses the most suitable colors and textures; when painting marble he creates a perfectly smooth, lustrous finish; and when painting a chapel, his opaline windows shimmer in the dark interior in a perfect optical illusion.

Eugène Fromentin
The Masters of Past Time, 1876

Fifteenth-century painting existed in a sphere in which the extremes of lofty mysticism and base materialism collided. Religious faith was an entity of such immediacy and pertinence that no earthly image was deemed

unsuitable to be used in a religious context. Van Eyck clothed his angels and divine figures in magnificent, heavy robes embroidered with gold and encrusted with jewels; celestial beings no longer need to be defined by fluttering drapery and swaying limbs [...]

With van Eyck, religious art attained a level of precision and naturalism that in many ways could be regarded as the beginning of an era. It was, however, the end of an era. Art had reached the final extreme in the necessity of depicting divine beings as human ones, and the mystic content of the paintings had all but vanished, leaving only the merest traces. For that reason, the naturalism of van Eyck, which many art historians have heralded as a foreshadowing of the Renaissance, instead marked the final expression of the late medieval spirit [...]

The content of van Eyck's paintings was still entirely medieval; there were no new ideas. It was a final resting point for the conceptual system of the Middle Ages, a system with a defined hierarchy from earth up to heaven. What van Eyck did was to gild it with gold and enhance it with vibrant colors.

Johan Huizinga
The Waning of the Middle Ages, 1919

Thus our question whether or not the still life-like accessories in our picture are invested with a symbolical meaning turns out to be no true alternative. In it, as in the other works by Jan van Eyck, medieval symbolism and modern realism are so perfectly reconciled that the former has become inherent in the latter. The symbolical significance is neither abolished nor does it contradict the naturalistic tendencies; it is so completely absorbed by reality, that reality itself gives rise to a flow of preternatural associations, the direction of which is secretly determined by the vital forces of medieval iconography.

Erwin Panofsky, "Jan van Eyck's Arnolfini Portrait,"
The Burlington Magazine, 1934

As a portraitist, van Eyck is simultaneously one of the most meticulous and one of the most enigmatic observers of human nature. His portraits suggest both intimacy and distance; generally speaking they are descriptive rather than interpretative. But in van Eyck's work, the descriptive process is one of reconstruction rather than simple reproduction, which puts his portraits in an altogether different category. It is difficult to comprehend the psychological

make-up, thoughts, emotions and circumstances of his sub-jects. However, it is precisely this absence of information, or its potentiality, that gives them a sense of ambiguity and ambivalence which in itself is extremely powerful. As ob-servers, we are both attracted to them and held aloof by them. They are characters whose psyches are hinted at, but not explored fully, whose intrinsic value remains independ-ent of time and place. Whatever the gaps in our own un-derstanding of them, they are essentially and recognizably human.

Erwin Panofsky
Early Netherlandish Painting, 1953

If any artist of the 15th century achieved a perfect harmo-ny of the real and the supernatural, it was Jan van Eyck. In his art the life of the spirit was truly embodied in its metaphorical vehicle, the physical world. The profundity of his intellect and the sublimity of his artistic expression, which combined an overwhelming verisimilitude with a spatial con-tinuum, all painted in glowing colors, was quickly acknowl-edged on both sides of the Alps.

Charles D. Cuttle
Northern Painting, 1973

The man of the late medieval middle-class epoch looks out on the world with different eyes and from a different standpoint than his forefathers whose interests were con-fined to the next world. He stands, as it were, on the edge of the road on which colourful, inexhaustible, relentless-ly onward-flowing life unfolds itself, and he not only finds everything that happens there extremely interesting but also feels himself involved in all this life and activity. The 'travel landscape' is the most typical pictorial theme of the age, and the pilgrim procession of the Ghent altar [by van Eyck] is to a certain extent the basic form of its world-view. [...] The onlooker no longer stands over against the work of art like the inhabitant of another world; he has been drawn into the sphere of the representation himself, and this identification of the surroundings of the scene represented with the medium in which the onlooker is himself first produces the complete illusion of space. [...] The fact that the artist of the Middle Ages is able to rep-resent real space—space in our sense—[...] is due to the 'film-like' view of things produced by the new dynamic attitude to life itself.

Arnold Hauser
The Social History of Art, 1960

When looking at a painting by van Eyck, we are invariably struck by the depth and detail of its illusion. We know that his contemporaries stood and gawked—as we do today—at the convincing, seemingly limitless, variety of his visual effects. There are the fuzzy curling locks of hair of childhood [...], the heavy woolen weave of oriental carpets, the crisp folds of satin brocades, the rich translucence of hand-blown glass [...], and the misty mountains of an expansive panorama [...] What is this detail—and our consequent fasciation—all about? For one thing, in his art van Eyck seems to have behaved like a child with a new toy: he could not get enough of it [...] His instinct for discovering fresh ways of representing the world must have overwhelmed him. It was so for his contemporaries, and remains so for us today.

Craig Harbison
Jan Van Eyck: The Play of Realism, 1991

The periphrase 'Beauty in all its mystery' is perhaps ideally suited to a discussion of van Eyck's *The Mystic Lamb*. It combines beauty and perfection like no other work of art. That is why his work is complex, and evades definition; it is inspirational, and yet simple [...]

Van Eyck's masterpiece does not actually evoke sentiments within us; it leaves us cold. Imposing and impenetrable, we can observe the magnificence of this panel without the slightest stirring of emotion within us: we can only lose ourselves in contemplation. It does not even seem to have been painted by human hand. There is no evidence of passion in the work, only an intensity, brilliance and nobility that lend it a supernatural dimension.

Harold van de Perre
Van Eyck, 1996

Locations

AUSTRALIA
Melbourne
National Gallery of Victoria
Ince Hall Madonna, 1433

AUSTRIA
Vienna
Kunsthistorisches Museum
Portrait of Jan de Leeuw, 1436
Portrait of Cardinal Niccolò Albergati, 1435

BELGIUM
Antwerp
Koninklijk Museum voor Schone Kunsten
St Barbara, 1437
Madonna at the Fountain, 1439
Bruges
Groeningemuseum
Madonna of Joris van der Paele, 1436
Portrait of Margarete van Eyck, 1439
Ghent
St Bavo's Cathedral

Polyptych of the Mystic Lamb (Ghent Altarpiece), 1424-1432

GREAT BRITAIN
London
National Gallery
Portrait of a Man (Léal Souvenir), 1432
Man in a Turban, 1433
The Arnolfini Marriage, 1434

FRANCE
Paris
Musée du Louvre
Madonna of Chancellor Nicolas Rolin, 1434–1435

GERMANY
Berlin
Gemäldegalerie
Madonna in a Church, c. 1426
Portrait of Baudouin de Lannoy, c. 1432
Portrait of Giovanni di Nicolao

Arnolfini, c. 1438
Dresden
Gemäldegalerie
Triptych of the Virgin and Child (Dresden Triptych), 1437
Kupferstich-Kabinett
Portrait Drawing of Cardinal Niccolò Albergati, c. 1431
Frankfurt
Städelsches Kunstinstitut
Lucca Madonna, c. 1437

ITALY
Turin
Galleria Sabauda
St Francis Receiving the Stigmata, c. 1428–1430
Museo Civico
Mass of the Dead, c. 1422–1424
Birth of John the Baptist, c. 1422–1424
Venice
Galleria Franchetti at the Ca' d'Oro
The Crucifixion, c. 1440–1450

THE NETHERLANDS
Rotterdam
Museum Boijmans van Beuningen
The Three Marys at the Tomb, c. 1426

RUMANIA
Bucharest
Muzeul National de Arta al României
Portrait of a Man with a Blue Chaperon, c. 1429

SPAIN
Madrid
Museo Nacional del Prado
The Fountain of Life, c. 1445–1450
Museo Thyssen-Bornemisza
The Annunciation Diptych, c. 1433–1435

USA
Detroit
The Detroit Institute of Arts
St Jerome in his Study, c. 1440–1442
New York
The Metropolitan Museum of Art
New York Diptych: Crucifixion, c. 1425
New York Diptych: Last Judgment, c. 1425
Philadelphia
Philadelphia Museum of Art
St Francis Receiving the Stigmata, c. 1428–1430

Washington
National Gallery of Art
The Annunciation, c. 1433–1435

Chronology

The following is a brief overview of the main events in the artist's life, plus the main historical events in his day (*in italic*).

c. 1390–1395
Jan van Eyck is born in the Netherlands. The place of his birth is not known for certain: it is likely to have been either Maaseyck (Maaseik), or possibly Maastricht, both in present-day Belgium. He is the younger brother of Hubert, also a painter.

1401
The competition for the design of the bronze doors of the Baptistery in Florence heralds the beginning of the Renaissance, with Brunelleschi's revolutionary discoveries in perspective.

1415–1417
Jan and Hubert van Eyck may have been in The Hague, working at the court of William IV, Count of Holland, Zeeland and Hainaut.

1422–1424
Documents show that Jan van Eyck is employed as a painter in the service of John of Bavaria, Count of Holland. He works on decorations for his palace in The Hague. Van Eyck is given the title "maestro" of his profession, and "valet de chambre," indicating his activities at court.
In 1422 Masaccio paints the San Giovenale Triptych.

1425
Van Eyck enters the service of Philip the Good, Duke of Burgundy, who grants him particular privileges, pays him a fixed salary, and allows him to work for other patrons. After a few months in Bruges, van Eyck moves to Lille, where he remains until 1428.
Founding of the University of Leuven (Louvain) the oldest Catholic university in Europe, which still remains a center of academic excellence.

1426
Van Eyck is remunerated by the Duke for a "secret mission." His brother Hubert dies this year.

1427
Van Eyck is paid to undertake another mysterious journey, this time to Tournai, where he has the opportunity to meet Robert Campin and Rogier van de Weyden.
Gentile da Fabriano dies shortly after completing his masterpiece, the Strozzi Altarpiece, *now in the Uffizi Gallery, Florence.*
Masaccio also dies, still only in his thirties.

1428
Van Eyck travels to Tournai again. Philip the Good sends him to Portugal as an official envoy, to negotiate his marriage to Isabella, daughter of King John I.

1429
He meets the King of Portugal at the castle of Aviz, where he paints two portraits of Isabella, now lost. The marriage contract is signed, and the ceremony takes place the following year, amid great pomp and splendor.

1430
Van Eyck moves back to Bruges.

1431
The powerful papal ambassador and cardinal, the Tuscan Niccolò Albergati, is entrusted by the pope with a delicate diplomatic mission that brings him to Arras and to Bruges. Van Eyck executes a famous drawing of him, now in Vienna.

1432
Van Eyck purchases a house in Bruges, where he is to stay for the rest of his life. He starts to sign and date his works, beginning with the *Ghent Altarpiece* in St Bavo's Cathedral, which he began with his brother Hubert in 1424, and completes by himself in 1432. He also signs *Portrait of a Man*, now in the National Gallery, London.

1433
Van Eyck paints and signs the *Ince Hall Madonna*, now in the National Gallery of Victoria, Australia. The

same year he signs and dates the magnificent *Man in a Turban*, now in the National Gallery, London. Philip the Good visits him in his studio.

1434
Birth of van Eyck's first child with his wife Margarete. Philip the Good is godfather, and presents him with six silver goblets made by Jean Peutin of Bruges. He signs and dates his most famous work, *The Arnolfini Marriage*, now in the National Gallery, London. *Cosimo de' Medici comes to power in Florence.*

1435
The salary of van Eyck is tripled, which leads to controversy. The treasurer's office in Lille refuses to make the payments, and Jan turns to the Duke of Burgundy for assistance. Philip the Good intervenes promptly, writing a placatory letter to his officials in which he extols the virtues of the artist, his involvement in grand projects as yet unfinished, and the fact that he is irreplaceable. The same year van Eyck is commissioned by the city council of Bruges to work on the façade of the Town Hall. *Publication of Leon Battista Alberti's treatise* De Pictura *in Latin; the following year (1436) it is published in the vernacular. This treatise is a formative work for the Renaissance, teaching artists how to achieve the correct use of perspective in painting.*

1436
Van Eyck paints the *Madonna of Joris van der Paele* (Groeningemuseum, Bruges), and *Portrait of Jan de Leeuw* (Kunsthistorisches Museum, Vienna).

He undertakes another secret mission for the Duke. René of Anjou is held captive in Lille by Philip the Good until 1437, during which time he is alleged to have made the acquaintance of van Eyck and to have received some instruction in the art of painting in oils.

1437
Van Eyck signs and dates the *Dresden Triptych* and the drawing of *St Barbara*, now in Antwerp.

1438
Fra Angelico starts work on the fresco cycle in the monastery of San Marco, Florence. The Council of Ferrara takes place.

1439
Van Eyck paints the *Madonna at the Fountain*, now in Antwerp, and the *Portrait of Margarete van Eyck* (in Bruges), his wife. The portrait is an important testimony as little else is known about her.
Piero della Francesco assists his teacher, Domenico Veneziano, in the cycle of frescoes in the church of Sant' Egidio in Florence.

1441
Van Eyck dies in Bruges. Documents refer to his funeral expenses, and to his burial in St Donation's churchyard. The following year, his brother Lambert, a lesser known painter in the service of the Duke, requests that his remains might be moved to a more privileged position within the church. The request is granted.

Literature

Max J. Friedländer, *Landscape, Portrait, Still-Life: Their Origin and Development*, Oxford 1949

Ludwig Baldass and Erwin Panofsky, *Van Eyck*, London and New York 1952

Erwin Panofsky, *Early Netherlandish Painting*, Cambridge (MA) 1953 (1966)

Robert Genaille, *Flemish Painting from Van Eyck to Brueghel*, Paris 1954

Valentin Denis, *All the Paintings of Van Eyck*, London 1961

Valentin Denis, *Van Eyck: The Adoration of the Lamb*, Milan 1964

François Cali, *Bruges: The Cradle of Flemish Painting*, London 1964

Charles D. Cuttler, *Northern Painting from Pucelle to Bruegel*, New York 1973

Craig Harbison, *Jan van Eyck: The Play of Realism*, London 1991

Otto Pächt, *Van Eyck and the Founders of Early Netherlandish Painting*, New York 1994

Craig Harbison, *The Art of the Northern Renaissance*, London 1995

Jeffrey Smith, *The Northern Renaissance*, London 2004

Jenny Graham, *Inventing van Eyck: The Remaking of an Artist for the Modern Age*, Oxford and New York 2007

Websites:
A website listing all his known works:
http://www.jan-van-eyck.org

Very close views of the Ghent Altarpiece can be found at:
http://closertovaneyck.kikirpa.be/#home

Photo credits